HAUNTED
FRANKLIN CASTLE

HAUNTED
FRANKLIN CASTLE

To John —
with love

WILLIAM G. KREJCI AND JOHN W. MYERS

Haunted
America

Published by Haunted America
A Division of The History Press
Charleston, SC
www.historypress.net

First published 2017

Manufactured in the United States

ISBN 9781467137430

Library of Congress Control Number: 2017940928

CONTENTS

ACKNOWLEDGEMENTS

The authors wish to thank their families and friends for the support they received while undertaking this lengthy project. A special debt of gratitude is extended to the following for their priceless contributions:

Kitty and Pascal with Oh Dear! Productions, LLC; Tim and Cori Walkden; Dora L. Wiebenson; Carl and Kari Tiedemann; Laurel Stanley; Anne Hammond; Carla and Art Branscomb; Krista Slavicek, Ben Gibson and Abigail Fleming with The History Press; Jim Dubelko; Ingo Brockmann; Cristine Bayly; Duncan B. Gardener; Michael Gaines; P. James Weideman; Mark Benbow; Elsie Ruhrkraut; Bob Ward; Gary Krueger; Elizabeth Horn; the Romano and Ocheltree families; Rachel Cisar; Doreen Lazarus; Lois Carelli; Connie Fleming; Elizabeth Colton; Helen Mirceta and family; Rick Perez; Kimberly Grimm; Robert Kokai and Allen Christopher; Louise Viola; Michelle Heimburger; Charles Cassady; Toni Geib; Michael O'Malley; Chuck Gove and Beth Richards with Haunted Cleveland Tours; Tim Barrett; Bill Byler and Cherokee Construction; Mary Levtzow; George and Mary Krejci; the Riverside Cemetery Association; the Cuyahoga County Archives; the Brooklyn Historical Society; the Western Reserve Historical Society; and the Ohio Historical Society.

1

ONCE UPON A TIME

Many of us have read this story before, either while browsing the newspapers around Halloween or looking through books on local hauntings. Perhaps we've found ourselves driving through the Ohio City neighborhood on Cleveland's west side and have caught ourselves admiring the many Victorian-era structures. Suddenly, we see a large and ominous sandstone home at the intersection of West 44th Street and Franklin Boulevard. It strikes us as very odd and out of place. We suddenly realize that this is the house we've read so much about. This is the legendary Franklin Castle.

Every time the story of the Franklin Castle has been told, it seems something new has been added to the legend. Still, the base tale is the same. When hearing the story, one conjures images of Shirley Jackson's *The Haunting of Hill House*. All the great gothic elements are in place for the perfect ghost story: a monstrous patriarch, incest, suicide, insanity, infanticide and murder. Later stories tell of Nazi spying and mass executions. For those unfamiliar with the legend of the Franklin Castle, it goes like this:

Back in 1860, a rich German immigrant named Hannes Tiedemann and his wife, Louise, built a large home on Franklin Boulevard in Cleveland. The Tiedemanns spared no expense building their home. Mr. Tiedemann, a bank executive, presided over his business with an iron fist. It was rumored that he governed his family in much the same way. In 1881, his daughter Emma died from diabetes, though it was whispered she was actually murdered by her abusive father. Stories also say that Emma was possibly insane or

promiscuous—sometimes one in the same back in those days. Two months later, Hannes Tiedemann's aged mother, Wiebeka, died at the Franklin Castle, likely of a broken heart.

In 1883, tragedy struck the family again with the deaths of three more children. All died within a week of one another and were buried at the family plot at Riverside Cemetery. It was whispered that Hannes had a hand in their demise. To deal with the grief, Louise busied herself by remodeling their home—adding secret passages, a turret and a ballroom on the fourth floor—and even had her children's faces carved in stone and placed as guardians to watch over the front entrance. The house now resembled a castle.

During that time, Hannes Tiedemann took a mistress. Rachel, a servant girl in the house, became the object of Mr. Tiedemann's affections. She remained so until another beau entered the picture. She and her new gentleman suitor were soon engaged, and on the day of her wedding, Rachel made the mistake of refusing Tiedemann's advances. This she paid for with her life. Legend says that Hannes Tiedemann strangled her in a secret passage that surrounds the ballroom but made it look like a suicidal hanging.

Another story relates that Hannes Tiedemann caught his niece, a girl named Karen, in bed with his grandson. In a fit of rage, he drew a gun and shot the girl dead. This, too, he made to look like a suicide.

In 1895, Louise Tiedemann drank herself to death. Within the year, Hannes Tiedemann returned to Germany, became reacquainted with a waitress named Henriette and returned with her as his new bride. He abruptly sold the Franklin Castle and moved with Henriette to an identical home he'd built in Lakewood. The new marriage was a disaster, and Henriette divorced the overbearing man, leaving him to spend his remaining years alone. She'd inherit nothing from his estate.

In 1906, Hannes Tiedemann's last surviving child, a son named August, died, leaving him without any heirs. Two years later, while walking in the park one Sunday morning in January, Hannes Tiedemann suddenly dropped dead. His death was from a stroke, but many suspected it was the hand of God himself that stuck down Hannes Tiedemann for the wicked deeds he'd committed in his long, horrible life.

The next owner of the Franklin Castle was a brewer from Buffalo named Muehlhauser. He rented the house to his widowed sister and her children, who lived there until 1921, when they sold it to the German Socialist Party.

During this next period, many wild stories emerged. Tales were told of Nazi spying during World War II and a giant radio antenna being placed atop the turret. Other stories told of illegal liquor production, rumrunning during Prohibition and a mass execution, with dozens gunned down in a secret room. Word also began to spread about hidden tunnels being discovered in the house. It was believed these tunnels were remnants of the Underground Railroad and were being used for smuggling liquor. The socialists owned the house until 1967, when it was sold to the Romano family.

Mrs. Romano and her husband purchased the house with the intention of turning it into a restaurant—though these hopes were soon dashed. On the day they moved in, two of the Romano children came down from the third floor and asked their mother if they could have a cookie for their friend, the little girl in white, who was crying upstairs. When Mrs. Romano investigated, she found nobody there.

Within a few weeks, the Romanos began noticing many more unusual events in the house. Objects moved around on their own, voices echoed from empty rooms and footsteps were heard running back and forth across the ballroom floor. Just two weeks after moving in, Mrs. Romano's two grown sons from a previous marriage awoke one night when the blankets were ripped from their beds. They moved out the following day.

Eventually, the disturbances were so great that Mrs. Romano forbade her children from playing on the third and fourth floors. On occasion, Mrs. Romano saw a woman in a black gown standing in the turret on the third floor, whom she believed was Louise Tiedemann. Others in later years gave her the identity of Wiebeka Tiedemann, Rachel or Karen. As for the little girl in white, many speculate it's the ghost of Emma Tiedemann. Word spread of what was occurring at the Franklin Castle, and soon the house drew reporters and curiosity seekers.

On one occasion, the house was visited by a radio personality named John Webster. While ascending the stairs, a recorder was ripped from his shoulders and smashed into dozens of pieces on the landing below. Another visit brought a writer for the *Cleveland Plain Dealer* named Barbara Dreimiller. While visiting the house, Dreimiller was ascending the same stairwell that Mr. Webster had. As she reached the top of the third floor landing, a green vaporous mist drifted ahead of her. Without hesitation, she entered this mist, was overcome and fainted on the spot. She awoke later on a sofa on the first floor.

Eventually, the house drove Mrs. Romano mad. One day, she received a warning from a medium that one of her children would die if she didn't

move. That was the final straw. After just five years of living there, the Romanos sold the home and moved elsewhere, never to return. Incidentally, moving her family changed nothing. One of her children died anyway.

The next owner was Sam Muscatello. His plans were to turn the house into a church, but after a few weeks, these plans were abandoned as the disturbances continued. While Muscatello was doing renovations on the third floor, a gruesome discovery was made. A human skeleton was found sealed up in a space between the walls. No identification of the corpse could be made, though it's suspected this was another victim of Hannes Tiedemann's ruthlessness.

The home was eventually sold to Richard Hongisto, the new Cleveland police chief. It was perfect for the large parties that he and his wife loved to host. Unfortunately, he'd only own this house for a few weeks. The Hongistos abruptly sold the house, driven away by the disturbances.

Next came George Mirceta, who, like the Hongistos, only owned the house for a brief period. He sold the Franklin Castle to man named Michael DeVinko.

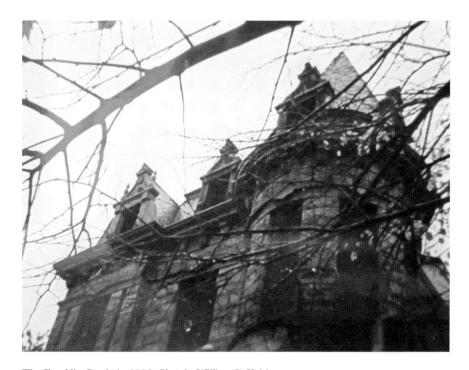

The Franklin Castle in 2006. *Photo by William G. Krejci.*

DeVinko was popularly known as Mickey Deans, Judy Garland's last husband. He'd purchased the house to accommodate the grand parties that he, like the Hongistos, loved to host. DeVinko made many changes to the house, adding and dividing up rooms. He owned the house until 1999, when he sold it to Michelle Heimburger, an executive and co-founder of Yahoo!

That fall, the Franklin Castle nearly met its destruction, as an arsonist broke into the house and set it ablaze. After the fire, Heimburger saved the house by having the roof replaced, though she'd ultimately sell the home to a real estate developer named Charles Milsaps.

Milsaps planned to convert the home into the Franklin Castle Club, an exclusive club that planned to offer an extensive wine bar, overnight stays and elegant dinners to its members. Very few renovations were made during Milsaps's time and the house was ultimately sold to a European artist, who planned to convert the structure into apartments.

The disturbances continue to this day.

All of this makes for a fantastic ghost story, and who doesn't love a good ghost story?

There's just one problem.

Hardly a word of this is true.

FROM SÜDERAU TO CLEVELAND

So what is the true story of the Franklin Castle, and who was Hannes Tiedemann, really? Was he the villain who appears in every telling of this story? Was he a monster capable of murder? Perhaps there's more to this story than any of us have heard. As with any legend, it's best to start at the beginning.

This beginning takes place in the small village of Süderau, Steinburg district of Germany, some 4,025 miles from Cleveland. Back then, this part of Germany was the state of Holstein in the Kingdom of Prussia. Our tale starts on April 12, 1832, with the birth of a boy named Johannes Tiedemann. His father, Hans, owned a blacksmith's shop located at Hof 887 Süderau, which had been purchased by his father, Claus, in 1799. Johannes's mother was the daughter of wealthy landowners Leutje and Anna Schueder Mohr, and her first name was actually Wiebke, not Wiebeka.

Johannes was one of eight children born into this family. He had four elder siblings: Claus, born March 4, 1823; Anna, born April 24, 1825; Ludwig, born March 16, 1827; and Catharina, born March 24, 1829.

The family was blessed with three more children following the birth of Johannes: Johanna, born October 15, 1834; Rebecca Eliese, born March 30, 1837; and Lowiese, born on August 3, 1842. Sadly, both Anna and Johanna died in childhood.

The yuletide season of 1846 fell upon the family with somber tones, as the family patriarch's health was deteriorating. Hans Tiedemann was ill for some time, and the blacksmith shop was now operated by his eldest son.

The final hammer fell on Christmas Eve of that year. Hans Tiedemann was dead at forty-nine. The day after Christmas, he was interred in the local churchyard at St. Dionysius Areopagita Lutheran Church. Wiebke was now a widow and the children fatherless. The future looked uncertain.

Now also came a troubled time for the Kingdom of Prussia, as war was brewing with Denmark over control of the duchies of Schleswig and Holstein. The Tiedemanns needed to make a decision. With Hans dead and war on the horizon, it seemed a good time to pick up roots and seek better opportunities elsewhere. The boys were already skilled tradesmen—perhaps America could offer more. Claus carried the blacksmith shop along pretty well, while Ludwig was employed as a merchant and Johannes as a joiner, an archaic term for a carpenter.

In the spring of 1848, Claus Tiedemann sold the blacksmith shop and the family relocated to Altona, a village near Hamburg, where Wiebke applied for herself and six children to emigrate from Prussia to the United States. Their original destination was listed as Wisconsin, likely Calumet County where many natives of Schleswig-Holstein were then settling.

That May, the Tiedemanns boarded the Danish brig *Manon* with 111 other passengers and sailed for America. On the voyage, Wiebke Tiedemann's eldest daughter, Catharina, met a man named Henning Bolten. Bolten, a manservant by trade, was also seeking a better life in America. As of late, he'd been burdened by a chronic cough and believed the travel would do him good. A relationship soon developed between Catharina and Henning.

The *Manon* docked in New York on May 27, 1848, and its passengers disembarked. There, the Tiedemanns were to continue to Wisconsin and began their journey west. They arrived in Cleveland, Ohio, in early June. Here they stopped. Perhaps this was as far as Henning Bolten was going and he invited them to stay with him. Perhaps this was as far as he *could* go and they decided to stay *for* him. This much is known. On June 18, 1848, just three weeks after arriving in the United States, Catharina Tiedemann married Henning Bolten in Cleveland.

As it turned out, Bolten's chronic cough was due to consumption, known today as pulmonary tuberculosis. Before he set foot on the *Manon*, his days were numbered. Time ran out for Henning Bolten on July 8, 1848, as consumption took his life. He and Catharina had been married just twenty days. He was originally interred at Erie Street Cemetery in Cleveland, but his remains were moved in 1909 to an unmarked grave at Highland Park Cemetery.

Ship's manifest from the Danish brig *Manon* showing the names of the Tiedemann family. *Courtesy of the National Archives.*

A few miles south of the city sat a parcel of land in Brooklyn Township, comprising 83.33 acres. On June 20, 1848, Wiebke Tiedemann purchased this parcel for $1,400. Much of this farm is now the city of Linndale, Ohio—specifically, the intersection of Bellaire Road and Memphis Avenue. Curiously enough, this transaction wasn't recorded until July 8, the same day that Henning Bolten died. Most likely, the money came from Catharina, Henning Bolten's sole heir. Immediately after making this purchase, Wiebke Tiedemann sold twenty-nine acres to her eldest son, Claus.

Seven acres of this land were plowed, and twenty-two were meadow. There were also two structures on the property, those being a barn and a small house. It was in that small house that the Tiedemanns began to make their way in America, the land of opportunity.

3
SITE-GEIST

The word *Zeitgeist*, of German origin, means "the spirit of the time." *Site-geist* is a word we invented to mean the spirit of the location.

When dealing with a place like the Franklin Castle, where paranormal activity is said to occur, it's appropriate to inquire about the history of the location and what happened there. Many believe that past events, trapped at a place in time, may cause a "residual haunting" or create an emotional presence. An example that comes to mind is the battlefield at Gettysburg.

Some have wondered if the Tiedemann house was built on an Indian burial ground. That is unknown but seems unlikely, as no remains have ever been located during any excavation on the site. The closest known Native American burial ground rests near the intersection of Lorain Avenue and Gehring Street, across from the West Side Market.

The known history of the Franklin Castle property begins when it was surveyed as part of the Connecticut Western Reserve. A large tract of land, originally part of Brooklyn Township, then known as Ohio City, was purchased in 1850 by Jacob Perkins, a son of surveyor Simon Perkins. His property was designated as the Jacob Perkins Subdivision. This contained Lot 94, an oddly-shaped triangular parcel on which Hannes Tiedemann would one day build.

Perhaps it was because of its strange shape, but it took Jacob Perkins ten years to find a buyer for Lot 94, a Canadian named Alfred Wolverton.

Alfred Wolverton's father, Enos, was born in New York State in 1810, and seven years later, Enos moved with his family to Huron County, Ohio, where his father, Robert, ran a stage line from Sandusky to Cleveland. The

family migrated to Michigan in 1825 and immigrated to Ontario, Canada, in 1826, where Enos married Harriet Newell Towl in 1834. They had two girls, Roseltha and Melissa, and five boys: Alfred, Daniel, Alonzo, Jasper and Newton. They settled in Blenheim Township, Oxford County, where the village of Wolverton was later named for them.

In 1855, Enos built a magnificent three-story brick house named Wolverton Hall, which had fourteen rooms and was adorned with a cupola. He also purchased one thousand acres of timber land in Walsingham Township, Norfolk County, and built a large steam sawmill. His wife, Harriet, died unexpectedly in 1856, and shortly thereafter, the general economy collapsed. Enos rented out Wolverton Hall and took his family to Walsingham to run his lumber business. Tragedy struck again in 1858, when his son Daniel was killed in a lumbering accident.

During that time, Enos Wolverton was selling lumber across the lake in Cleveland to a company called Thatcher, Burt and Company. Traveling there on a trip with his father, Alfred thought it a wonderful place to receive an education. Unlike the village of Wolverton, there were no schools in the lumber woods of Walsingham, so in 1858, Alfred and Jasper Wolverton were sent to Cleveland for their education.

April 1860 found Alfred and Jasper at the head of their class at Eagle Street Grammar School and looking to attend West High School in the fall. They'd been living in a boardinghouse but planned to build a home. At the end of the school term, they were joined by their youngest brother, Newton. Alfred spent much of his time looking for a site on which to build. One of the salesmen at Thatcher, Burt and Company, a retired lake captain named Joseph J. Cartwright, told Alfred of some lots that were available just up the road from his own home on Franklin Street. That July, the oddly shaped Lot 94 was purchased by Alfred Wolverton for $500, and construction commenced.

Enos Wolverton shipped the lumber for the project to Cleveland, where Thatcher, Burt and Company received, unloaded and delivered the materials to the building site. The house would be a two-story frame home with clapboard siding and wood shake roofing shingles. Another structure being erected was a sizable carriage house at the northwest corner of the property, just behind the home. Joining the Wolvertons that fall was their brother Alonzo, who stayed through the winter before retuning to Ontario to help his father in the lumber mill.

By winter, the house was taking shape and, although not completed, was habitable. Also residing at the new house was their former housekeeper from

Ontario, Mrs. Grimes, who, like Alonzo, also remained until the following spring. The Wolverton boys had dubbed the house Bachelors' Hall, and it bore the address 283 Franklin Street. Construction on the house was piecemeal and took time. This was because the boys were full-time students and part-time builders.

In May 1861, Alfred and Jasper Wolverton were at the top of their classes at West High School; their brother Newton had been named valedictorian at Eagle Street Grammar School.

That April, the Civil War began, and money was growing tight. The Wolvertons had invested much into their house on Franklin and decided that enlisting with the Union army would be a great way to earn some money to continue their educations. Most agreed the war wouldn't last longer than a month or so, and the boys believed they'd be back in their classrooms that fall. On July 21, 1861, Alfred, Jasper and fifteen-year-old Newton Wolverton enlisted with thirty-five other men. They were attached temporarily to the Fiftieth New York Infantry and sent to Washington, D.C. Once there, they were transferred to the quartermaster's department as teamsters.

Shortly after his three brothers enlisted, Alonzo returned to Cleveland to finish the house they'd been building on Franklin. After completing the house, Alonzo visited his brothers in Washington and took employment with the quartermaster's department. Throughout the summer, Alfred sent money back to Cleveland to a friend named Alexander L. Beswick, who made payments in his name to help settle debts that arose from building Bachelors' Hall.

A slightly fictionalized account of the Wolvertons' lives in Cleveland and the army can be found in the book *Four Went to the Civil War* by Lois E. Darroch, Alonzo Wolverton's granddaughter. This book is mostly composed of the brothers' letters to their sister Roseltha and offers a good picture of Cleveland at the time, as well as certain events of the war. Another good source is the book *Dr. Newton Wolverton, an Intimate Anecdotal Biography of One of the Most Colorful Characters in Canadian History*, written by Newton's son, Alfred N. Wolverton.

Just a few months after enlisting, seventeen-year-old Jasper Wolverton died from typhoid fever on October 12, 1861. Alfred was given a furlough and took Jasper's body back to Canada for burial.

Around that time occurred an incident known as the Trent Affair, in which a Union gunboat, the USS *San Jacinto*, stopped a British vessel named the *Trent* and removed from it two Confederate emissaries. Pressure was put on President Lincoln to declare war on Great Britain, as it appeared to some

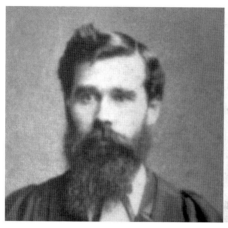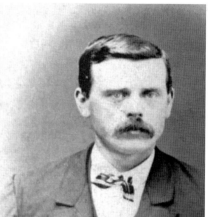

Newton Wolverton, circa 1877, and Alonzo Wolverton, date unknown. *Courtesy of the Archives of Ontario and Cristine Bayly.*

that the British were aiding the South. This greatly concerned the nearly fifty thousand Canadians serving with the Union army. A war with Britain meant war with Canada. Fearing war, these Canadians sent the now sixteen-year-old Newton to meet with President Lincoln to voice their concerns.

"Mr. Wolverton," the president told him, "I wish you to go back to your boys and tell them that Abraham Lincoln appreciates the value of their service, and that so long as Abraham Lincoln is president, the United States will not declare war on Britain." The president was true to his word.

During the Civil War, disease killed more soldiers than combat. Such was the case with twenty-four-year-old Alfred Wolverton, who died at Kalaranna Hospital in Washington, D.C., on April 24, 1863, from smallpox. Newton had visited him that morning, but when he returned in the evening, he was told that Alfred was dead and buried. Smallpox victims were interred as quickly as possible. Originally interred at Columbian Harmony Cemetery, a paupers' graveyard, Newton orchestrated Alfred's reburial in Glenwood Cemetery, in grave no. 67, with a beautiful cedar tree and stone at his head.

Newton stayed in Washington for a brief time after his enlistment expired. During that time, he became acquainted with another boarder at the rooming house where he resided, the noted actor John Wilkes Booth.

Following Alfred's death, Alonzo received a letter from his father asking if he'd done anything about the Franklin Street property, selling or exchanging part of it, to make it square. As previously stated, it was an oddly shaped lot,

narrow in the front and wide in the back. The answer to his father's question was no. He'd leave that to the next owners to correct.

On June 29, 1863, Newton left Washington, returning home to Ontario, where he served as an officer with the Twenty-Second Oxford Rifles. While enlisted in this militia, Newton was stationed in nearby Woodstock, Ontario, and befriended a man from Ohio who was working for the railroad named Thomas Edison.

That fall, Alonzo traveled back to Cleveland, where he briefly resided at the Franklin Street house. During his stay, he purchased the property from his brother Newton, his sisters Roseltha and Melissa and their respective husbands. The following January, he enlisted with the Twentieth Independent Battery, Ohio Light Artillery. He was captured in combat but escaped. That October occurred a skirmish in Dalton, Georgia, where again he was taken prisoner and held at Villanow, Georgia. He was paroled after signing a form stating that he would never take up arms against the Confederacy, though neither side tended to honor such agreements.

On November 30, 1864, came the battle at Franklin, Tennessee. Although it only lasted a few hours, there were many casualties. Among those injured was Alonzo. One shot grazed his left cheek, and another struck him in the leg. Despite these injuries, he remained on active duty.

Two weeks later occurred the battle of Nashville, Tennessee, where again Alonzo distinguished himself. The next day, he was promoted from corporal to second lieutenant and reassigned to the Ninth U.S. Colored Heavy Artillery, Company D, where he remained until receiving his discharge on August 2, 1865.

In April 1865 came the news that President Lincoln had been assassinated. This greatly upset Newton Wolverton, as it was President Lincoln who'd assured him that the United States wouldn't declare war on Canada or Great Britain. To make matters worse, the president's assassin was Newton's former neighbor, John Wilkes Booth.

Word spread that Booth might try to seek refuge in Canada. Newton was contacted by U.S. and Canadian officials and was requested to come to the border to inspect people crossing into Canada. Newton would have no trouble identifying Booth. He arrived at the border to learn that Booth had already been killed.

Newton became a Baptist minister and taught mathematics at Woodstock College. He worked briefly in Brantford, Ontario, where he befriended Alexander Graham Bell and assisted him in his workshop. Newton established a meteorological observatory and later became president of a

black Baptist college in Texas. Today, Newton Wolverton is recognized as the father of modern meteorology in Canada. He died on January 31, 1932, in Vancouver, British Columbia.

After receiving his discharge, Alonzo Wolverton returned to Cleveland and stayed for two and a half months. The Franklin Street house was now empty. Gone were the sounds of laughter and the happy times that he'd spent with his brothers in a city that changed their futures. There was nothing left for him but somber memories of times long ago.

Alonzo Wolverton sold Bachelors' Hall and returned to Ontario, where he married, raised a family and worked in his father's lumber trade. He died at Wolverton Hall in 1925.

This is quite a surprising back story about one little property on what was just a small street that ran along a sandy ridge in Cleveland—odd that none of it has ever been mentioned in relation to tales of the Franklin Castle until now.

4

A BRAVE NEW WORLD

Seven members of the family Tiedemann arrived in New York Harbor thirty-eight years ahead of the Statue of Liberty. The Old World was behind them, and the New World, with all its possibilities, lay ahead.

For the next few decades, Wiebke would watch and guide her children as they made their way. There was land to buy and homes to build. There were vows to share and children to bear. Most of it would take place in Ohio, and the heart of the story would always center on Cleveland.

Wiebke sold half of her Brooklyn Township property to her son Claus in 1848. She deeded the remaining 54.33 acres to him on October 3, 1853. An adjoining 69 acres in Rockport Township were added in 1866. It was in Brooklyn that much of the family would remain for the next few years. In addition to Claus and his mother, the farm was also home to Wiebke's youngest child, Lowiese.

Living two farms up the road was Rebecca Eliese, the second-youngest daughter, who worked as a servant for the James W. Day family. Catharina, who'd gone back to using her maiden name, remained in Cleveland and worked as a servant in the home of a draper named Salmon A. Powers.

Ludwig, the second oldest of the Tiedemann children, set out for northwest Ohio, and by 1850, he was living in the town of Defiance, where he worked for an ashery. Ludwig remained at this occupation throughout most of his life. Also, he left the Lutheran faith for the Methodist Church, becoming an elder of the community and later a minister at St. Paul's Church in Defiance.

As many other immigrants did after arriving in this country, Ludwig Anglicized his name to Lewis and shortened his surname to Tiedeman. Today, there's a street in Defiance that's named for him. Lewis shares this distinction with his eldest brother. Tiedeman Road in Brooklyn, Ohio, was named for Claus, though it's actually misspelled. Claus never shortened his surname. The mistaken spelling appearing on the road can be traced to when his name was accidentally shortened on land maps, and the error was carried over in the naming of the road.

Shortly after arriving in the United States, Johannes Tiedemann shortened his name to Hannes and took an apprenticeship on the farm of a man named Simeon Enos in Parma, Ohio. The main operation of this farm was a cooperage, or barrel manufacturing shop. Hannes already had experience in this field as a joiner, working in his father's blacksmith shop back in Süderau.

It should be noted that Hannes Tiedemann's early apprenticeship has been mentioned in publications, though on every occasion, even in his obituary, the location named is North Royalton. The fact is that Hannes Tiedemann never worked in Royalton. The farm in Parma where the Enos cooperage existed wasn't sold until August 1855. At that time, the Enos family relocated to Royalton.

Hannes remained with the cooperage in Parma until 1854, when he decided to seek greater opportunity in the city. After returning to Cleveland, he found

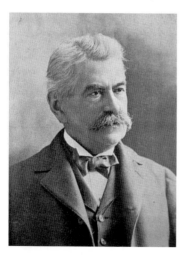

employment as a traveling salesman and clerk with the wholesale grocery firm of Babcock, Hurd and Company. A year later, Hannes Tiedemann became a naturalized U.S. citizen.

Shortly after beginning his job with Babcock and Hurd, Hannes befriended another German immigrant named John Christian Weideman, who was employed as a salesman for a rival grocery firm called Edwards and Iddings. John and Hannes remained friends for the rest of their lives.

By 1862, the American Civil War was fully engaged, and no doubt, this brought back memories of earlier civil unrest that had taken place in Hannes's beloved homeland and precipitated his family's

John Christian Weideman, circa 1897. *From* Cleveland und sein Deutschthum, *1898.*

move to the United States. This was a time for him to reflect on his life and make plans for the future. He'd now grown into a handsome young man, standing five feet, eight inches tall, with gray eyes and sandy blond hair. Half of his siblings were married, starting families of their own, and Hannes felt the need to join them.

Catharina found herself a new husband in a man named Gaston G. Allen on October 31, 1852. Gaston, the eldest son of William Allen Sr. and Dorcas S. Burdick, was born on March 30, 1822, in LeRay, New York, and arrived in Cleveland with his family around 1832. Like Catharina, Gaston had also been previously married. On January 2, 1848, Gaston married Eveline Adell Johnson of Newburg, Ohio, but they had only been wed for a year and a half when twenty-one-year-old Eveline died on June 25, 1849.

Gaston would prove to be an excellent husband, as well as a very motivated individual. Shortly after he arrived in Cleveland, he entered into an apprenticeship to become a journeyman ship's carpenter, a trade he maintained for many years. His most notable achievement was his membership in the fraternal order of Free and Accepted Masons. He was mostly affiliated with Bigelow Lodge No. 243, the first Masonic lodge on the west side of Cleveland, where he was elected the first Worshipful Master in 1854. He also made the first set of jewels for Bigelow Lodge as well as the aprons and rug before the altar.

The Allens' Cleveland residence throughout much of that era was a home on the corner of Franklin and Hicks Streets. In 1857, they briefly stayed at a boardinghouse on Pearl Street, now West 25th Street, where they were joined by Wiebke Tiedemann, who lived with them on and off for many years to come. In 1859, they relocated with Wiebke to a home on Root Street, now West 47th Street.

Claus Tiedemann remained in Brooklyn, where he continued to farm his eighty-three acres. On October 26, 1856, he married Emielie Baumgart, a daughter of German immigrants Frederick August and Sophia Rossow Baumgart. Claus and Emielie Tiedemann had eight children: Elizabeth, Paul, Anna, twins Fritz and Wilhelmina, Claus Jr., an unnamed stillborn son and Emilie. Many of their children would marry and remain in the area of the family farm.

Even Hannes's younger sister, Rebecca Eliese, who now went by Eliza, was married by this point. She'd wed a man from Dover, Ohio, now the cities of Bay Village and Westlake, named Lyman Perry Foote on October 24, 1857. Foote was the son of Thomas and Diadama Perry Foote, settlers from Lee, Massachusetts. Like Gaston G. Allen, Lyman had also been married once

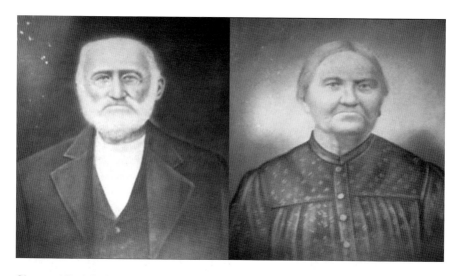

Claus and Emielie Baumgart Tiedemann, circa 1907. *Courtesy of Tim and Cori Walkden.*

before. His first wife, Ruth Berry Smith, died on July 19, 1855, at the age of thirty-one.

In the winter of 1862, Hannes Tiedemann boarded a ship and traveled back to his hometown of Süderau in search of a wife. His youngest sister, Lowiese, accompanied him.

Hannes's future bride was Louise Höck, the daughter of Juergen and Wilhelmine Christine Schultze Höck. She was born in Süderau on May 10, 1837. Louise's father was a prestigious member of the community and more educated than most. Juergen Höck was the village schoolmaster and the organist at St. Dionysius Areopagita Lutheran Church, the Tiedemanns' home parish. Louise was a childhood friend of the Tiedemanns and likely often played with Eliza and Lowiese. It's not known how long the courtship existed between her and Hannes, as it is possible they'd been exchanging letters for years. This is very likely, as Hannes Tiedemann received his first U.S. passport on July 22 of the previous year, a necessary preparation to travel abroad to marry. Wedding bells rang out for Hannes and Louise on March 19, 1862.

Four days later, Hannes Tiedemann and his new bride boarded a 301-foot, three-masted iron vessel named the *Bavaria* and set out for home. They disembarked in New York City on April 10, 1862, just two days before Hannes's thirtieth birthday, and returned to Cleveland. That autumn, Hannes and Louise were expecting their first child.

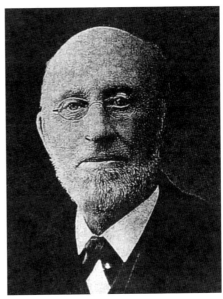

Left: Louise Höck Tiedemann. *Right*: Hannes Tiedemann. *Courtesy of Dora L. Wiebenson.*

After receiving the good news, Hannes moved himself and his young bride into a home he rented from his brother-in-law Lyman Perry Foote at 112 Hanover Street. This home, a wooden frame house, was situated just four addresses northeast of Franklin Circle on what is now the east side of West 28th Street.

At that time, new opportunities were presenting themselves in Hannes's life. In 1861, John C. Weideman opened a wholesale liquor and grocery firm with a man named Jacob D. Hildebrand. Two years later, he sold his interests in the firm to Hildebrand and immediately formed a new partnership with Hannes Tiedemann under the name Weideman and Tiedemann, Wholesale Liquor and Grocers.

Weideman and Tiedemann was opened in a small shop at 70 Merwin Street in the Cuyahoga River flats, just a few doors east of the current location of the Flat Iron Cafe. In this enterprise, Hannes Tiedemann built his fortune.

In early June 1863, Louise Tiedemann gave birth to their first child, a daughter they named Wilhelmine. Tragically, the joy of her birth was short-lived. Two months later, on August 10, 1863, Wilhelmine died from consumption. Hannes was a man of limited means and had no plan

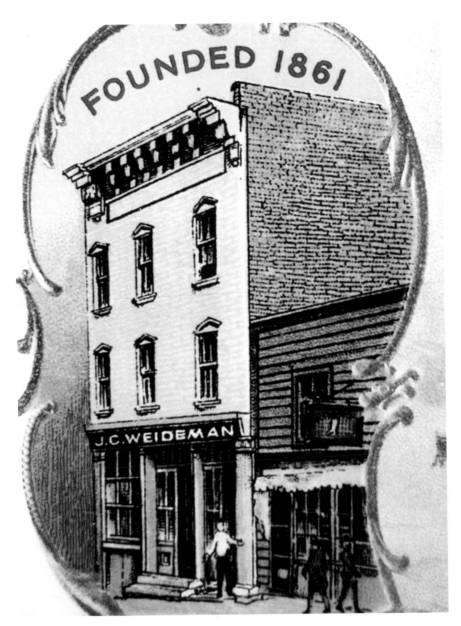

Weideman and Tiedemann on Merwin Street, as depicted on a cigar box label from the Weideman Company. *Collection of William G. Krejci.*

August Johannes Tiedemann, circa 1874. *Courtesy of Dora L. Wiebenson.*

for burial expenses. His brother-in-law Gaston G. Allen owned a family plot at Monroe Street Cemetery in Cleveland and was more than willing to allow young Wilhelmine to be buried there. She was interred in Section B, Lot 19, Southwest 1/4 Tier.

That following winter, Louise was again expecting and gave birth on September 28, 1864, to their second child, a healthy blue-eyed boy named August Johannes. Louise was again with child by the spring of 1865. A growing family meant that the Tiedemanns needed a larger house.

When the family began to look for a new home, they didn't need to go very far. Just a few blocks west, they found a wonderful frame house with a carriage house behind it and a wide green yard in the back that was more than large enough to allow their children plenty of room to play. It was an oddly shaped lot situated along Franklin Street and was still close enough for Hannes to travel to work in a timely manner.

The well-built home was occupied by Alonzo Wolverton, a twenty-four-year-old Canadian man. He and his three brothers had come to Cleveland to further their educations but found themselves involved in the American Civil War. Disease had claimed the lives of two of his brothers, and now the house held nothing more than empty memories of happier days long gone. Alonzo was ready to return to Ontario.

Alonzo Wolverton sold the property at 283 Franklin Street to Hannes Tiedemann on October 19, 1865, for $3,000. To avoid the sales taxes, the property was deeded in Louise's name. Hannes and Louise's third child, a daughter, was born in November of that year, just after the family settled into their new home. They named the blonde-haired baby girl Emma.

By then, the war had ended, and like all wars, some businesses prospered and fortunes were made, while some lost everything and were financially ruined. Of greater import was the tremendous effect the war had on the personal lives of individuals and families, especially for those in uniform and actively involved in the fighting. Many, including the Tiedemanns, were touched by the drama of the war.

Emma H. Tiedemann, circa 1874. *Courtesy of Dora L. Wiebenson.*

When the first shots of the Civil War were fired on Fort Sumter on Hannes Tiedemann's twenty-ninth birthday, there was a rush of men enlisting with the Union army. Hannes's brother Lewis joined up with the Ohio 100th Infantry on June 6, 1862. Afterward, he was transferred to the 8th Tennessee Cavalry, where he was promoted to second lieutenant. Lewis Tiedeman received his discharge on February 6, 1864, and returned

to Ohio to take on the charge of administering a Sunday school at the Broadway Church in Toledo.

Eventually, Lewis returned to Defiance, where on January 7, 1867, he married Helena Ann Harley, a twenty-two-year-old daughter of German immigrants Christian and Regina Stelzer Harley. Lewis and Helena had six children: Perry, Anna, twin daughters Tilla and Lillian, Charles and a daughter named Cora. Sadly, both Charles and Anna wouldn't live beyond infancy. Lewis's family remained in Defiance until the late 1890s, when they returned to Toledo.

Gaston G. Allen also enlisted with the Union army. He served for one hundred days with the Ohio 150th Infantry, whose charge it was to garrison fortifications around the nation's capital. The only fighting they participated in was the battle before Washington, D.C., against General Jubal Anderson Early's corps on July 12, 1864. Just a few months before enlisting with the Union army, Gaston purchased a house on Taylor Street, now West 45th Street. He and Catharina lived there with Wiebke for only four months. Perhaps out of fear that the fighting would reach Cleveland, Gaston sent Catharina to live in Davenport, Iowa, with family friends. Accompanying her on this trip were her youngest sister, Lowiese, and her mother. Gaston joined them in late 1865.

In early October 1866, Hannes and Louise Tiedemann decided to correct their oddly shaped property on Franklin Street once and for all. They entered into an agreement with the men who owned the property just to the east, exchanging thirty feet from the back of the Tiedemanns' property along Vine Court with thirty feet of frontage on Franklin Street. This meant that they'd lose a considerable amount of their backyard but would gain quite a bit up front. The property was now a perfect rectangle measuring 63 feet by 167 feet.

Now as the nation started to return to a state of normality, the business of Weideman and Tiedemann grew faster than it could accommodate. By 1867, they had moved into a larger building up the block at 30 Merwin Street. A new partner was also added to the firm, Oliver Granger Kent, a noted horse breeder, philanthropist and longtime friend of future president James A. Garfield. The new name for the business was Weideman, Tiedemann and Kent.

Gaston and Catharina Allen left Davenport in 1868 and returned to Ohio, but rather than live in Cleveland, they chose to reside in the small lakeside community of Vermilion, where Catharina's sister Eliza was living with her husband. Lyman was involved in the shipbuilding industry in that

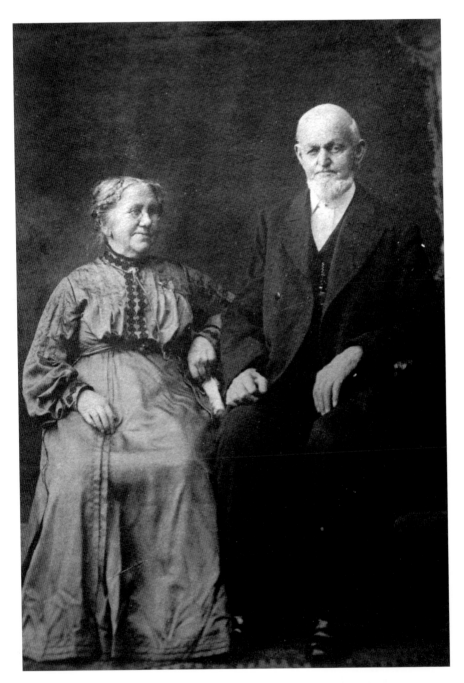

Catharina and Gaston G. Allen. *Courtesy of Dora L. Wiebenson.*

town, and Gaston, a skilled ship's carpenter, found opportunity to pursue his trade. The Allens remained in Vermilion until 1873.

Lowiese Tiedemann opted to stay with the Allens in Vermilion, where she met her future husband, Henry Thompson, who worked with Gaston and Lyman. Lowiese, the youngest and the last of Wiebke Tiedemann's children to marry, became Henry Thompson's bride on November 21, 1871. They had two children, a son named John and a daughter named Katie Belle Thompson. Katie married a man named George Smith, who died before their fifth anniversary. They had no children, and Katie never remarried. Her brother, John, remained a bachelor.

In 1868, Hannes took his wife and children on a trip back to Germany. Six years earlier, he'd gone there to find a wife. This time, they returned so they could visit with friends and relatives but especially so that Louise could see her parents again and give them the chance to meet their grandchildren.

When they returned to the States on September 22, 1868, they were accompanied by a young woman named Christine Kerina. Christine was from the Tiedemanns' home village and sought to immigrate to America. She lived with the Tiedemanns for a few years and worked as a servant in their home. This was the beginning of a benevolent pattern of behavior for the Tiedemann household. Frequently, when German immigrants arrived in Cleveland, Hannes provided them with a place to stay until they were able to find employment and a residence of their own. Hannes had a well-earned reputation of being a generous man and benefactor in the German American community.

Also, in 1868, when Gaston and Catharina Allen moved to Vermilion and Lowiese chose to stay with them, Wiebke returned to Cleveland. It may be that the home in Vermilion was too small for the four of them, but it seems more likely that Wiebke wanted to be closer to her sons Claus and Hannes and their families. She moved in at 283 Franklin Street with Hannes's family.

In December 1869, there was yet another addition to the Tiedemann household. Ernst S. Tiedemann became the fourth child born to Hannes and Louise, but once again, the joyous excitement was cut short. Ernst died almost seven months later, on July 10, 1870, from brain fever, which today we know as meningitis. He was laid to rest beside his sister at Monroe Street Cemetery.

It is important to note that childbirth back then, unlike what we are used to, was fraught with danger. Most children were born at home. When labor began, the doctor or midwife was sent for and hopefully arrived

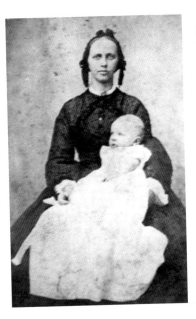

Louise Höck Tiedemann with unknown child. *Courtesy of Dora L. Wiebenson.*

in time to assist. Even then, there was a higher mortality rate for both the mother and child than what we're accustomed to today. In some cases, there would be later complications connected with the birthing process. Along with these complications, there were infant and childhood diseases that could easily prove fatal. Parents in the 1800s knew that life was a fragile gift. Today, we think that children are supposed to bury their parents, but not long ago, many parents had the sad task of burying their children. Our cemeteries are a testament to this. What happened to Hannes and Louise wasn't unusual.

The Tiedemanns were sustained as they watched their children, August and Emma, continue to grow. Added joy was given to the family on May 29, 1871, with the arrival of their fifth child, a daughter whom Hannes and Louise named Dora Louise.

April 1870 saw the arrival of a new neighbor for Hannes and Louise Tiedemann. John C. Weideman purchased the property immediately to the west of the Tiedemanns. Just around the time that Dora was born, the Weidemans built a house on that property and resided there for the next few years. In 1877, John Weideman sold that house to his only surviving son, Henry, and moved into a grand home at 194 Franklin Street.

Oddly, just as Weideman was becoming the Tiedemanns' neighbor, Hannes decided to withdraw from his partnership in Weideman, Tiedemann and Kent, and by late May 1871, Hannes had removed himself from the firm altogether. By this time, he'd amassed a sizable fortune in the grocery trade and figured it was time to move on. He sold his interests in the grocery firm to Oliver Granger Kent and began a career as a private capitalist, purchasing properties around the greater Cleveland area and focusing on real estate investments. These investments paid off quite well in years to come.

On July 19, 1872, Hannes Tiedemann's brother Claus purchased a fifty-four-acre farm—just up the road from his farm in Brooklyn

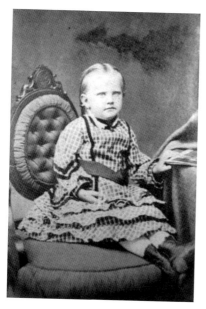

Dora Louise Tiedemann, circa 1874.
Courtesy of Dora L. Wiebenson.

Township—from a man named Patrick McPhillips for $6,300. The property already contained a two-story Italianate home. It was in that house that Claus raised his family. The road it sat on would one day bear his name. Over the next few years, he and Emielie sold off their original farm to the north in what is now Linndale.

In the late spring of 1873, Louise Tiedemann gave birth to her sixth and final child, Albert, who died a couple months later on July 8, 1873. He'd be the last of the Tiedemann children buried at Monroe Street Cemetery.

The death of young Albert was just one of three major events that affected Hannes Tiedemann that year. The second was the return of Gaston and Catharina Allen to Cleveland. They'd purchased a home at 40 Root Street, now 1827 West 47th Street, just a few doors down from their previous residence. Wiebke Tiedemann left Hannes's house and once again lived with the Allens. At this time, Gaston had taken a job as a carpenter with the shipbuilding firm of Radcliffe & Langell. Eliza and Lyman Perry Foote had previously moved back to Cleveland, where Lyman entered the pile driving industry and purchased a home at 341 Franklin Street, just a few blocks west of Hannes Tiedemann's house. It was there that Lyman and Eliza raised their two daughters: Cora Elise and Helen Perry Foote. Their home still stands at the address 4706 Franklin Boulevard.

The third major event to occur in Hannes's life in 1873 was his subsequent involvement with a neighbor on Harbor Street named Bernard McGroder, a blacksmith, who'd also dabbled in tinkering with new ideas. Early that year, he and Hannes came up with an idea for an improved marine salvaging device that would receive a patent on September 9 (Pat. No. 142,712). The McGroder-Tiedemann Wrecking Apparatus revolutionized the marine salvage industry as a new method for raising sunken vessels from deep water.

On October 25, 1875, Hannes Tiedemann followed his brother Claus's example and made a real estate purchase that he'd utilize for himself.

The purchase was from Henry Beach and comprised 4.34 acres of land that stretched between Lake Erie and Lake Avenue in East Rockport, now Lakewood, Ohio. Hannes was planning something big, something that wouldn't stop there but would carry over as an idea for his property on Franklin. Although he didn't know it at the time, it was an idea that would guarantee his name to be carried on long after he'd be gone. The idea was simple enough.

Hannes Tiedemann would build a house.

5

THE TURNING POINT

Building a new home in East Rockport at that time was quite *en vogue*. Most of Cleveland's well-to-do residents were seeking solace from the congestion of the city and erecting summer residences. When we think of such getaways today, we commonly think of an escape to the Lake Erie Islands region or something of that nature. At that time, however, most of East Rockport was still considered country, and there were plenty of properties that offered splendid vistas of the lake. If you take a leisurely drive down Lake Avenue today, in the area of West 117th Street, you'll notice some remnants of these grand homes. Many were given names such as Shady Cove, Shoreland, Ednawood, Roseneath and the like, though in many cases, these names are all that remain. Occasionally, one finds a low stone wall along the front of a property. These walls end in short pillars on which the names of these estates are engraved. Sadly, nearly every single one of these homes has since been razed.

Just as plans for construction on the East Rockport property were commencing, Hannes Tiedemann found himself—presumably under the encouragement of his brother-in-law Gaston G. Allen—becoming involved with the Masonic order. He became a member of Bigelow Lodge No. 243.

On May 25, 1876, Hannes and Louise Tiedemann signed over power of attorney to their longtime friend John C. Weideman. This enabled him to act on their behalf in any legal or business matters in their absence. The reason for them doing this was because they were planning on being away for a long time. Seeing that August, Emma and Dora were still quite young and

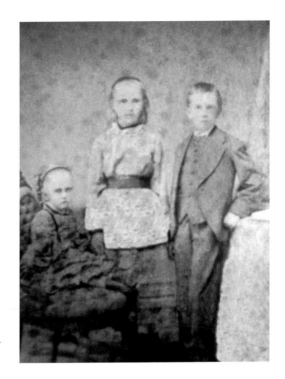

Dora, Emma and August Tiedemann, circa 1874. *Courtesy of Dora L. Wiebenson.*

impressionable, Hannes and Louise decided that living abroad in Germany for a few years would be a wonderful experience. They could take in the culture and history of their homeland and become better acquainted with distant cousins they hardly knew.

On June 12, 1876, the Tiedemanns caught a steamer in New York bound for Germany and remained in that country for three years. While the Tiedemanns were living abroad, John C. Weideman rented out their Franklin Street house from mid-1878 until the summer of 1879. The tenant was Dr. Dimont M. Caldwell, a medical examiner for the Mutual Life Association of Cleveland.

At the close of their trip to Germany, the Tiedemanns boarded a vessel in Hamburg named the *Westphalia* and arrived in New York Harbor on September 23, 1879. Joining them was a twenty-nine-year-old woman named Louise Pollitz.

Pollitz was born in Krempe, Steinburg, Prussia, in 1849 to parents Otto Heinrich and Cacilie Margarethe Munster Pollitz. The eldest of three children, she was the first to come to the United States, seeking a better future for herself. Her family knew the Tiedemanns, and stories of Hannes's hospitality preceded him. It was no surprise that Louise was invited to

Emma Tiedemann, circa 1876. *Courtesy of Dora L. Wiebenson.*

join them in America and stay in their house. That autumn, Louise Pollitz was living with the Tiedemanns as a boarder and possibly even assisted as something of a nurse.

It was a sad truth throughout all of this that Emma Tiedemann, Hannes and Louise's eldest living daughter, was suffering from type 1 diabetes. It's possible that the recent trip to Germany might also have been so that Emma could receive treatment, as Germany claimed to offer advanced facilities for treating such diseases. As to whether or not these treatments were effective, one could only guess. Insulin wouldn't become medically available until 1921, and suffering from diabetes was, in 1879, a very painful thing to endure. The afflicted were commonly struck with bouts of severe hunger, thirst and, in most cases, dehydration. Under extreme circumstances, flu-like symptoms, weight loss and blurred vision occurred. All that Hannes and Louise Tiedemann could do was hope and pray for the best. Perhaps, they thought, rest and relaxation at their new summer residence would help to ease her condition.

The first announcement of Hannes building a new home in East Rockport came on March 6, 1880, when a notice was placed in a magazine titled the *American Architect and Building News*. This periodical

featured stories from around the country that focused on the construction of new buildings, the grandest showpieces the nation had to offer. This notice appeared in the "Summary of the Week" column under the heading for Cleveland Houses, which read: "Messrs. Cudell & Richardson are preparing plans for Mr. Tiedemann for a two-story frame summer residence on Lake Avenue: cost, $8,000."

Anyone familiar with the history of the Franklin Castle has surely heard the names Cudell and Richardson. After all, those are the names that are engraved on the side of the Franklin Castle as architects of that structure.

John Newton Richardson was born on February 28, 1837, in Perth, Scotland, where he received his formal education before moving to Canada in 1856. There he apprenticed to a carpenter until 1859, at which time he came to the United States. In 1862, he volunteered with the Union army and served during the Civil War. Two years after the war's close, he went to work as a draftsman for the architectural firm of J.M. Blackburn and Associates. He remained there until early 1870, when he entered into a partnership with Frank Edward Cudell, thus founding the firm Cudell & Richardson, Architects. On September 15 of that year, he was married to Martha Ann Wood. They had two sons, Francis and Edward, both named for his business partner, Frank Cudell. John Newton Richardson became a naturalized U.S. citizen on June 27, 1871.

Franz "Frank" Edward Cudell was born on May 11, 1844, in Herzogenrath, Germany, to parents Dr. Karl and Louise Krauthausen Cudell. He received his education first in his hometown and later at the technical college in Aix-La-Chapelle, Germany. He came to the United States in 1866 and stayed first in New York, where he worked with the noted architect Leopold Eidlitz. He arrived in Cleveland the following year and took a job as a draftsman.

In 1869, Frank's two younger brothers, Adolph Anton and J. Robert Herman Cudell, followed him to the United States but continued on to Chicago, where by 1870 they, too, were working as architects. It was also in 1870 that Cudell and Richardson were boarding together in the home of Mr. U.D. Shaw in Cleveland.

The partnership with John N. Richardson proved at once to be a success for Frank Cudell. He took all of his knowledge of German architecture and applied it to nearly every project the firm undertook. Their first project was the designing and construction of the Triumphal Arch on Public Square, erected for the Victory Celebration in 1871. Later that same year, they completed their first sacred structure, St. Joseph's Roman Catholic Church in Cleveland. Other well-known churches and buildings would follow,

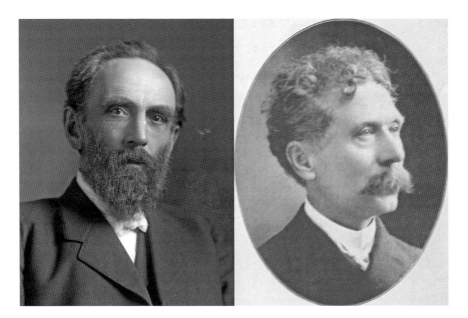

Left: Frank Edward Cudell. *Courtesy of Cleveland Public Library Photograph Collection. Right*: John Newton Richardson. *From* Men of Ohio in Nineteen Hundred, *1901.*

including the Franklin Circle Christian Church in 1874 and the Jewish Orphan Asylum in 1888. They were famously known also as the designers of many of Cleveland's social gathering places such as the Odd Fellows Hall, the Freemason's Temple and Germania Hall. Both Frank Cudell and John Richardson became Fellows of the American Institute of Architects.

Frank Edward Cudell was considered by most accounts to be a very interesting man, quite a character according to those who knew him. He stood just over five feet, nine inches tall, had brown eyes, dark brown hair and was slightly disabled, as he had a drooping shoulder and walked with an uneven gait. He'd often joke around about his bad shoulder, claiming that he'd received the injury during building activities as an adolescent. He was best known for his integrity, civic spirit, idealism and sense of fairness.

There was one incident in particular when Frank Cudell hired a friend and neighbor, a very skilled artisan, to do some interior decorating on a house he was commissioned to design. Somewhere down the line, the two came to a disagreement that caused a heavy conflict, resulting in a legal battle. Frank Cudell lost the lawsuit and complied with paying his bill. Interestingly enough, the next time he required wall decorations, he hired the same man. When asked by colleagues why he'd do such a thing, Cudell

replied by saying, "Why, I wouldn't think of anyone else. Why should I retaliate? We had an issue, and it was decided against me. I must have been wrong." Not many would take that approach.

Frank Cudell was married twice, first to Marie Hessenmüller, who died in 1887, and then to Emma Müller, a daughter of former lieutenant governor Jacob Müller, in 1889. His only child, Dr. Adolph Cuddell, died in August 1903. Adolph, a prominent physician, drowned with a colleague while swimming in Lake Erie near the German-American Club House.

The firm of Cudell and Richardson was dissolved following the completion of the Perry-Payne Building around 1890, when Frank Cudell withdrew primarily due to ill health. John Richardson continued working in the architectural field by going on to build the Jennings Apartments in 1898 and the Powerhouse in the Flats.

John Richardson passed away on May 6, 1902, in Cleveland and was buried at Riverside Cemetery. He was sixty-six. One of the last homes he designed was a fine estate named Roseneath for pioneer automaker Alexander Winton on Lake Avenue in East Rockport, just a few doors west of the Tiedemanns' summer estate.

Frank Cudell, now retired, became involved in the civic group planning of the city of Cleveland. In the five years between 1903 and 1908, he published three books on the subject. He proposed a centrally located railroad terminus away from the waterfront, which he believed should be retained as park space. Some may consider Cudell to be the father of the Terminal Tower. He offered a plan to redesign the layout and development of downtown Cleveland, but it was unfairly attacked and rejected by Mayor Tom L. Johnson's administration.

Frank Edward Cudell passed away at his home on West Boulevard and Detroit Avenue on October 25, 1916, and was interred in Lake View Cemetery beside his first wife and son. The year following Frank Cudell's death, his wife erected a clock tower in his honor on their property. In fact, Cudell himself had actually designed the tower, yet it had never been constructed. Oddly, the clock has no hands, and therefore, it is as timeless as his memory. Upon the death of his widow in 1937, the property was deeded to a niece and later, through a wish in Cudell's will, was donated to the City of Cleveland to be used as a park and recreation area. The home is currently the Cudell Arts and Recreation Center.

The Tiedemanns' East Rockport house has been mentioned a few times when tales of the Franklin Castle have been told. Almost every time, it's said that this house was identical to the Franklin Castle. This was definitely not

the case. The East Rockport house, while also featuring a tower-like structure, was actually a gabled home. It was accented by many dormers—but not of stone—and not nearly as elaborate as those found on the Franklin Castle. The house was a half-timbered Stick-style home and reflected greatly the country estates of northern Germany. It was accented by a lavish porch with a grand veranda located directly above. It also had a splendid view of the lake. In many ways, the property that this house sat on would have felt more like being in a park-like setting with its green lawns, gardens and large trees. The original plans called for a two-story house, but it ended up being a larger structure than first imagined.

Country estates were very popular among the privileged class. Even John C. Weideman owned a large home up the street from the Tiedemanns on the northwest corner of Lake Avenue and Highland Street, now West 117th Street, called Waldmere. It was at these summer homes where many of Cleveland's wealthier families would take their retreat, oftentimes bringing their servants with them to stay for the season.

As the fall of 1880 pressed on toward winter, the Tiedemann family looked forward to the completion of their summer residence and highly

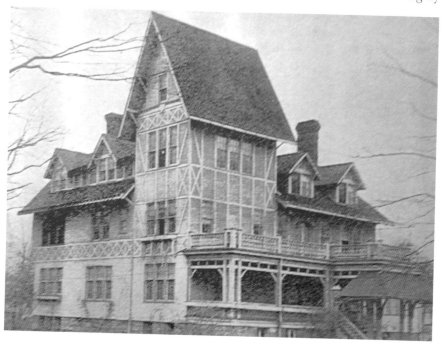

Steinburg, the summer residence of Hannes Tiedemann in East Rockport, Ohio. *From History of the City of Lakewood, 1915.*

anticipated spending their next summer there. With some luck, the cool lake breeze and park-like setting would help to improve Emma's failing health. Thus far, she'd managed to keep her diabetic condition under control, but shortly before Christmas of that year, her health began to deteriorate. The holidays must have been a very somber time for the family and without much celebration. As the new year of 1881 was ushered in, Mr. and Mrs. Tiedemann could only pray that their daughter's health would improve. It would only have been natural for Hannes Tiedemann to wish to trade places with his dying daughter. Emma carried on for the next two weeks suffering from nausea and fatigue, as well as a painfully unquenchable thirst. The situation was grim.

Then, on the night of Saturday, January 15, 1881, Emma H. Tiedemann succumbed to her illness. Hannes and Louise's beloved daughter was dead. The following morning, Dr. Julius C. Schenck confirmed the death. Arrangements were made that day for Emma's funeral. A casket was purchased and the hearse ordered, but a burial location still needed to be selected. Being more financially well-off and not wanting to impose on his brother-in-law again, Hannes Tiedemann purchased a family plot at the recently opened Riverside Cemetery on Pearl Street. There, in section 22, the whole family could be laid to rest together, when the time came.

Emma Tiedemann's casket was placed in the parlor of the Tiedemanns' home on Franklin Street, and on Monday, January 17, 1881, the funeral service was held. The guests arrived at 3:00 p.m. to pay their respects to the family and to bid farewell to the child they'd all watch grow into a young lady. From there, the funeral procession made its way to the gates of Riverside Cemetery. The final prayer service was held in the chapel, and the mourners departed.

After the family had left, Emma's casket was taken down into the room beneath the chapel where it was tagged and sat for nearly two months. There was no mysterious reason for this and no last-minute autopsy was performed, as some who believe her death was from a sinister cause have claimed. Rather, the reason was that the winter of 1881 was extremely cold and harsh. Back then, graves were dug by hand, and with the ground being frozen, this would've been nearly impossible.

So it was that on March 18, 1881, Emma's remains were finally laid to rest and a stone placed above her with this epitaph: EMMA—DIED JAN. 15, 1881—AGED 15 YRS. 2M.

Grief at the loss of young Emma spread throughout the family, and everyone did what they could to continue on. August immersed himself into

Left: Emma Tiedemann, circa 1880. *Courtesy of Dora L. Wiebenson.*

Below: Tiedemann family burial site at Riverside Cemetery in Cleveland. *Photo by William G. Krejci.*

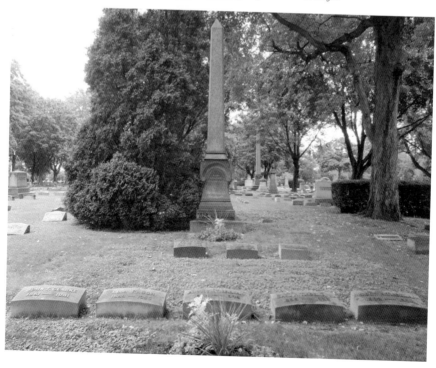

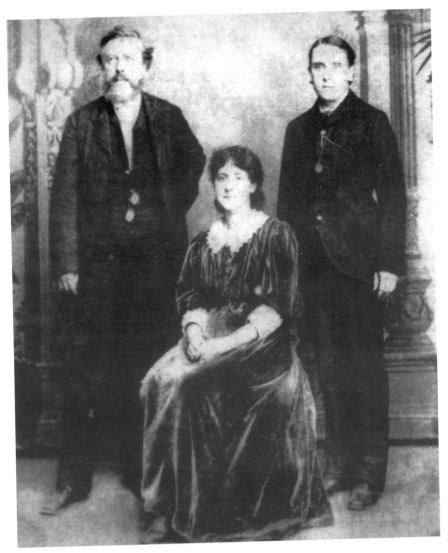

Hannes, Louise and August Tiedemann, circa 1881. This photo was discovered in the Franklin Castle many years later. *Courtesy of Brooklyn Historical Society.*

his schoolwork. After graduating, he took a job as a clerk with his father's former business partner John C. Weideman.

Tragedy struck the family again on April 11 of that year, as Wiebke Mohr Tiedemann passed away, not even three months after Emma. Her cause of death was ruled simply as old age, though it's quite possible that she'd been ill for some time. Previously written accounts concerning the death

of Wiebke Tiedemann claim that she'd died at the Franklin Castle. This, however, was not the case. She actually died at the home of her daughter Catharina and son-in-law Gaston G. Allen—where she resided for the last eight years—on Root Street.

As it was a hard winter with a deep freeze and Emma had to wait nearly two months to be interred, so, too, did Wiebke. Her remains wouldn't be buried until May 14. She was laid to rest only a few feet away from Emma. Her epitaph on the family monument states that she was eighty-four years of age, though having been born on November 20, 1797, she was actually eighty-three.

Wiebke Mohr Tiedemann, circa 1880. *Courtesy of Dora L. Wiebenson.*

Indeed, the years between 1876 and 1881 were pivotal in the lives of Hannes Tiedemann and his family. They were the turning point leading up to the building of the house that history would one day come to know as the Franklin Castle. As soon as the East Rockport house was completed that spring, he moved his family there and began the demolition of the old Franklin Street house, reducing all the sorrowful memories it held to rubble and dust.

6

HIS HOME IS HIS CASTLE

While it's true that construction on the house history would come to call the Franklin Castle wasn't officially started until 1881, plans for a change on the property were conceived on June 1, 1876. It was then that an agreement was made between Hannes Tiedemann and his neighbor and former business associate John C. Weideman, who owned the property just to the west. The agreement was for the installation of a sewer line to run across the Weidemans' property. John and his wife, Laura, agreed to the terms and to share the future costs of repairs and replacement of this sewer line with Hannes and Louise Tiedemann. The line would tie into the new home Hannes would soon build on Franklin Street. Hannes was planning improvements on his Franklin Street property before he even boarded the vessel that would take his family abroad for three years.

It has long been debated as to when the Franklin Castle was actually constructed. Many publications have given years like 1860, 1865, 1880 or 1883. The Cuyahoga County Auditor's Office even gives a construction date of 1867. Few in recent years have actually gotten the date of 1881 correct. Clues to this are left all around the house in the smallest of details, from the hardware used to the style of the fireplaces, mosaic floor and trim work. Further clues are found in the county assessor's books at the Cuyahoga County Archives, where a property value drop of more than $500 is recorded in 1881, and by 1883, a $6,000 property value increase is shown. Also, there's a detailed image from the City Atlas of Cleveland, Ohio, in 1881 that depicts no structure on the site, the first house having

been demolished and the second still being erected. Construction for the Franklin Castle was completed in late 1882 or early 1883.

It should be noted here that it was during this era that Franklin Street became Franklin Avenue. The reason for this change is unclear, though it would not be the last time that the designation would be altered.

In the designing of this new Franklin Avenue house, Hannes Tiedemann again chose to employ the architectural firm of Cudell & Richardson. When construction on the Franklin Castle began, Frank Cudell employed his knowledge of German architecture now more than ever. It was evident that Hannes Tiedemann wanted a home that emulated the great dwellings found in his native land. Cudell & Richardson was more than happy to oblige.

With two twenty-three-year-old men—Charles F. Thiele Jr. and Louis Wangelin—as draftsmen on the project, plans were drawn up, and construction of the new house commenced. Also assisting on the project was a twenty-nine-year-old man named Peter Kohnz, who not only worked for Mr. Cudell but also boarded with his family.

To begin with, the original name of the house was not the Franklin Castle. The fact is, it had no name. Houses in the city were not given names by their owners. They were simply known by the names of the families that occupied them. The distinction of giving homes fancy names was reserved for country estates and summer residences. Hannes Tiedemann also observed this practice. The name he chose for his East Rockport residence was Steinburg.

Secondly, many people have theorized that the Tiedemanns simply had their original house modified in 1881 by adding secret passageways, a turret, ballroom and stone faces. This again was not the case. The City Atlas of Cleveland from 1881 plainly shows the Franklin Avenue property with no house located on the site.

When completed, the house was a true showpiece of the area. The style has often been debated, with some claiming that it's of Gothic Revival design while others contest that it's Victorian, Chateauesque or Romanesque. While Victorian describes the era it was built, this is a vague and loosely used term. The best description of the house comes from architectural historian Tim Barrett, an architectural designer and consultant for the City of Cleveland.

"Stylistically this is a High Victorian Eclectic–styled house," stated Barrett. "Simply, it is a mixture of styles, as is the norm with many late nineteenth-century buildings. The double-pitched, or mansard roof is from the Second Empire style. The towered asymmetrical façade celebrates the then-popular Queen Anne style."

Along with these styles, there are many other subtle influences at work. The beautiful sandstone dormers are of an Ogee design, partially concave and partially convex, and are more reminiscent of the Flemish style. The whimsical Queen Anne style specifically features turrets, ornamental dormers, balconies and porches and generally exhibits an animated exterior, which this house certainly has.

Of the many wonderful features this house has to offer, the ornate doorknobs and hinges found throughout seem to immediately grab everyone's attention. These fixtures were primarily made by Branford Lock Works of Branford, Connecticut. Also found are a few pieces from Russell & Erwin.

The home is filled with a variety of wonderful hardware pieces, many of which feature images of butterflies, flowers and sparrows. These were done in the Eastlake style, named for Charles Locke Eastlake, who wrote the book *Hints on Household Taste in Furniture, Upholstery and Other Details*. Most of the pieces that appear in the house can be found in hardware catalogues from 1881. Wanting to keep up with the latest styles, Hannes Tiedemann selected the most recent designs available.

It's also a good bet that Hannes Tiedemann wanted to maintain a constant motif throughout the house and also would've had the Eastlake style represented in his furniture and wall décor. Many hints still remain in the house that reinforce this idea. The two massive fireplaces on the second floor are unmistakably of the Eastlake style, as are the numerous hand-carved floral details that flank a majority of the interior doorways.

The many magnificent features of this house vary from floor to floor, and it's best to address each level as if one were taking a tour of the home. Imagine if you will that the Tiedemanns have just moved in and have given us special permission to take this chance to view their splendid home.

Our carriage enters through the low front gate and rolls up the brick driveway to the side entrance, where the coachman stops the horse. We exit the carriage beneath a steeply sloped porte-cochère and are greeted at the door.

Now, it'd be best to start this guided tour on the first and lowest floor, commonly referred to as an English basement. This first level is where the servants reside. Entering the home from the driveway side, or east entrance, we first come onto a landing and are faced with a set of stairs ahead of us that would take us either up to the left or down to the right.

Coming down onto the servants' level, one immediately notices the lavish hardwood floors, magnificent white oak wainscot paneling and door trim and beautiful gas-lit light fixtures. Instantly, we come to a room on our right.

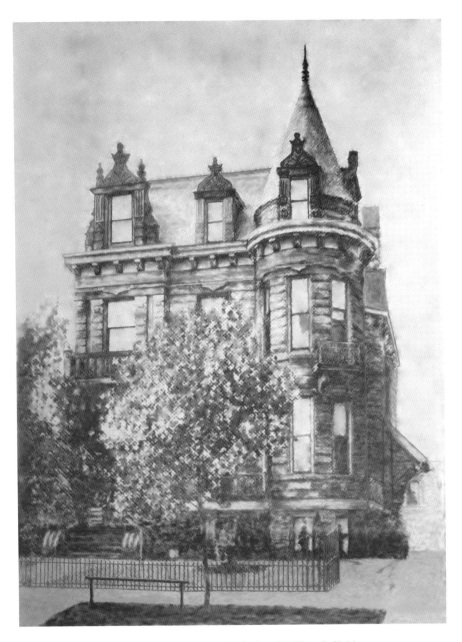

Earliest known photo of the Franklin Castle. *Collection of William G. Krejci.*

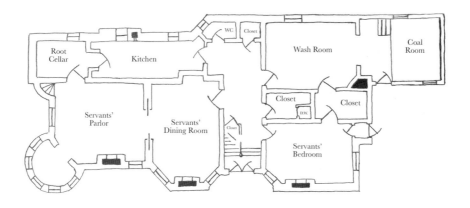

Floor plan of the Franklin Castle's first level, as it originally appeared when the house was complete in 1883. *William G. Krejci.*

This is the servants' bedroom. It features a walk-in closet and has its own back entrance and fireplace. In all, the house contains thirteen fireplaces. Continuing down the corridor, we next come to a dumbwaiter service that runs to the fourth floor. This is ideal for bringing food trays up from the kitchen to the dining room, as well as carrying steamer trunks to the guest bedrooms upstairs. Beyond this and on the right is a washroom and, through that, the coal room. At the end of the corridor, straight ahead, is a small bathroom that contains a toilet and a sink. There's no bathtub in the house at this time, and baths have to be taken at the public bathhouse up the road. Still, indoor plumbing and a toilet are definite luxuries for this time. Furthermore, Frank Cudell was also an inventor, and in 1878, he invented the ball sewer gas trap that prevented sewer gasses from backing up into houses. It would definitely have been incorporated here.

At the end of the corridor, on the left, is the kitchen where a wood-burning stove, a sink and an ice chest are found.

Turning back toward the stairwell, on our right we find the doorway that leads into the servants' dining room, opposite the dumbwaiter. Here, too, we find a lovely fireplace. Continuing on through this room, we come to a set of pocket doors. Through these, we enter the servants' parlor, where we find another fireplace, a mate to the one in the dining room. We also notice the beautiful wooden Colonial blinds featuring Eastlake-style latches. Across the room, there's a doorway that leads to the right and into a small room that connects to the kitchen. This is the root cellar.

Door hinge, doorknob and key escutcheon plate from Branford Lock Works with mosaic tile floor in front foyer of the Franklin Castle. *Photo by William G. Krejci.*

Back in the servants' parlor, we see a narrow stairwell in the southwest corner, spiraling up slightly to the second floor. Walking up this stairwell, we find a narrow sliding pocket door that leads us into the foyer, just inside the main entrance. We step through the small pocket door and, after closing it, find that it blends in perfectly with the surrounding red oak wainscot paneling. So well is this pocket door hidden that had we not just come through it, we'd not even have known it was there. The floor in the foyer is beautifully adorned with a mosaic tile design not unlike those found in Eastlake's book. The purpose of the stairwell we have just ascended is so that the servants could answer the front door without having to walk through the entire house.

We continue up to the second level, through the glass double doors, and enter the main part of the home.

We're now standing in a long and wide corridor at the front of the house. The ceiling here is twelve feet high. Ahead and to our right, we see two doors. Entering through the first, our attention is immediately drawn to a wonderfully ornate fireplace, built to emulate a dark green and black Italian marble that showcases a beautiful mirror above the mantel. The fireplace is actually carved slate and has a faux finish. The ceiling carries fine plaster molded details, and the furniture here is of the highest quality and comfort.

We also notice two other things right away. First off, we see a difference in the style of the door hinges. On the first level, they carry a flowing floral design, while the ones on this floor feature butterflies and bamboo. These are from Branford's Oriental line of hardware.

The other thing that we notice is the rounded nook across the room accented by many narrow windows. This is the interior of the turret, maybe the most recognizable feature from the outside of the house. Two of these windows are actually cleverly disguised doors that lead out onto the front

53

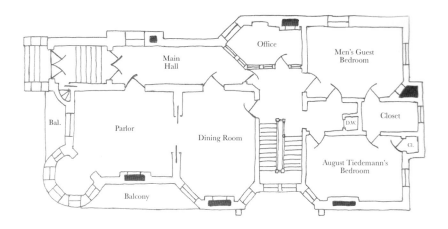

Floor plan of the Franklin Castle's second level, as it originally appeared when the house was complete in 1883. *William G. Krejci.*

and side balconies. The window sashes actually open completely by passing into a cavity in the ceiling. This grand and elaborately decorated room that we are in is the parlor, primarily used for entertaining when friends and relations come to call.

Continuing across the parlor and passing through a set of mahogany pocket doors, we enter the Tiedemanns' dining room. Here we find a beautiful gas-lit chandelier, a table large enough to accommodate the family as well as guests and another fireplace matching the one we just viewed in the parlor. The only difference between these two fireplaces is that this one is finished to emulate a reddish Italian marble. Two doors lead out of this room: one into the corridor we first entered from and another that takes us to the back of the house.

We reenter the corridor from which we started, at the end of which is a glassed-in office that adjoins the back corridor. Here, Hannes Tiedemann does much of his work at home. The office is trimmed in redwood, as are the cabinets, shelves and drawers. It also contains its own fireplace. Another nice feature about having this glassed-in office was that whenever a guest came to call, Mr. Tiedemann could see his visitor without even having to leave his desk. Both the front and side entrances are visible at a glance.

Stepping from the office and into the back corridor, we see directly ahead of us and down a short flight of steps, the doors through which we first entered the house. In this corridor we see on our right a door that

takes us back into the Tiedemanns' dining room. On our left, we see an alcove with two doors leading off of it: one to the left and one to the right. Straight ahead in this alcove is where the dumbwaiter service lets off on the second floor.

Walking first through the door on our left, we find ourselves standing in a guest bedroom. This room was reserved for male guests who stay with the family. Tucked in the corner sits a fireplace. Leaving this room and crossing the alcove, we find ourselves in the bedroom of August Tiedemann, Hannes and Louise's eldest child. August is in his late teens by now, and the décor of his bedroom reflects this. Of course, he has a bed and bureau in here, but the style of these are quite masculine. He also has a small desk, just a place where he could sit in privacy and compose letters. This bedroom is also equipped with a fireplace, likely a match to the one in the previous bedroom, though not tucked into the corner but placed on the east wall, directly above the one in the servant's bedroom on the floor below. Across the room is a very small cloakroom and another door. Through this door is a walk-in closet, which is shared with the guest bedroom across the hall, thus the previous room would have been reserved for male guests.

Leaving this bedroom and retreating from the alcove, we find ourselves once again in the back corridor facing the stairs. We ascend these, come to a landing where we turn to the right in a 180-degree fashion and continue up to the third floor, where again, the ceiling is twelve feet high.

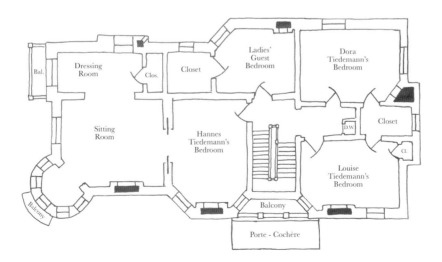

Floor plan of the Franklin Castle's third level, as it originally appeared when the house was complete in 1883. *William G. Krejci.*

At the top of the stairs, we see a door straight ahead of us and, on our right, another alcove similar to the one on the second floor, where we see the dumbwaiter and two sets of doors. The bedroom that sits directly in front of the stairs was reserved as a guest bedroom for female visitors, which also contained its own walk-in closet and a fireplace, which is located directly above the one downstairs in Mr. Tiedemann's office.

Turning to the right and entering the alcove, we enter the door on our left, which takes us into the bedroom of Dora Louise Tiedemann, Mr. and Mrs. Tiedemanns' youngest child. As she's only about twelve at this time, we'd find personal effects fitting a girl of her age, porcelain dolls and the like. There's also a smaller bed and vanity. At the foot of the bed sits a trunk that holds items of value to Dora. Later, it'll be used as a hope chest. Across the room, located in the right-hand corner, is an ornate fireplace. Beside this is the entrance to a walk-in closet.

Departing this room and entering the one across the alcove, we find ourselves in the bedroom of Hannes's wife, Louise Tiedemann. It's a fact that in some Victorian families, the husband and wife didn't share a bedroom. Having separate bedrooms for spouses, however, was a luxury only afforded by the wealthier class. This bedroom, being directly above August's, matched his as far as having a closet and fireplace in the same locations.

Exiting this bedroom and alcove, we pass the stairs on our left and guest bedroom on our right and enter the master bedroom that is occupied by Hannes Tiedemann. The amenities in this room are some of the grandest in the house. The gas lights are extremely ornate as are the bed and bureau. The fireplace on the east wall is of white Italian marble and features a federal shield. Another thing this bedroom features is its own balcony. Stepping through a narrow window and out onto this balcony, we see that it's accented by a hand-carved sandstone railing and spindles. This balcony faces east and offers an impressive view of the neighborhood. At the other end of the balcony, we see that it adjoins with another room, that being Mrs. Tiedemann's. This balcony was used by Mr. and Mrs. Tiedemann so that they could discreetly see each other at night without disturbing the rest of the house.

Off of Mr. Tiedemann's bedroom, through a set of pocket doors, we enter his personal sitting room. Here, the furniture is equally as luxurious and comfortable as that found one floor below in the parlor. This room also features a white Italian marble fireplace, a mate to the one in Mr. Tiedemann's bedroom. Like the parlor below, it also boasts a circular nook, the third floor of the turret. Here, another narrow window in the

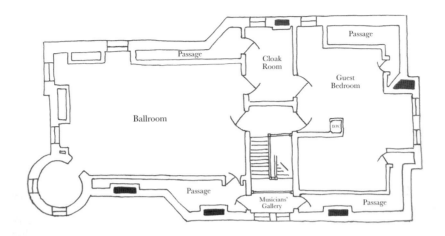

Floor plan of the Franklin Castle's fourth level, as it originally appeared when the house was complete in 1883. *William G. Krejci.*

center leads out onto a small sandstone balcony with iron railings. Across the room on the right is an arched entryway that leads to a long alcove that serves as Mr. Tiedemann's dressing room. On the left is another window that leads to yet another sandstone balcony, which sits directly above the front entrance of the house.

Returning through the dressing room, sitting room and Mr. Tiedemann's bedroom, we retreat once again to the back of the house. We come to the stairs and press on to the fourth floor. Just as before, we reach a landing, turn to the right and continue up.

The first thing that we notice, as we reach the fourth and topmost floor, is the small balcony that overlooks the landing between the third and fourth floors. This is a musicians' gallery. When the Tiedemanns host large gatherings, they'll have a string trio placed on this balcony, playing fine music for the guests as they arrive. The wonderful thing about the placement of this gallery is that the music can still be heard—yet not too loudly and overpowering—throughout the fourth floor.

At the top of the stairs, we reach two doors, one to our left and one to our right. Through the left-hand door, we enter the vast ballroom where the Tiedemanns host their many parties. It features hardwood floors, elegant gas-lit chandeliers and an open space measuring twenty-four by thirty-two feet. On the far end of the room are two sets of windows with built-in window seats. The one on the right is much larger than the other, which sits

in the center of the wall. On the far left is another circular alcove. This is the topmost part of the turret. With an impressive view of Franklin Avenue below, a couple can slip away from the excitement of the gala and take in the cool evening air from the tower room. Here also in the ballroom sits a piano, as Dora Tiedemann is quite a talented pianist. It should also be noted that the walls here taper in slightly, following the shape of the mansard roof.

Returning to the doorway through which we entered the ballroom, we notice to our right a slender door tucked slightly out of the way in the corner of the ballroom. This is the access to the musicians' gallery and to a passage that runs the length of the ballroom, used primarily for storage. It's this space in between the walls that many in later years would regard as a secret passage, though there is nothing secretive about it. The entrance is in plain view.

Exiting the ballroom, we find ourselves back at the top of the stairs. Across from us is another door. We enter this door and are now in one more guest bedroom. Off of this guest bedroom are two more passageways and a door that leads back into the cloak room. This back bedroom has one completely out-of-the-ordinary feature though. Carefully hidden in the floor is a trapdoor. Lifting up this door reveals a space in between the floors large

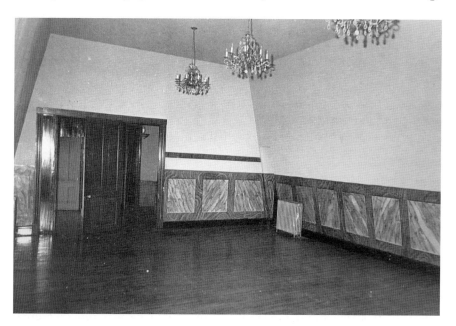

Fourth-floor ballroom. *Courtesy of the Cleveland Public Library Photograph Collection.*

enough for a person to enter. We are now in a shallow passage running between the third and fourth floors. This passage follows back for a short distance and abruptly ends in a wider room. The height of the passage and room is only about three feet. We are in the trunk space, where servants and house guests store their steamer trunks after arriving and emptying the contents into dressers and closets.

Above this fourth floor is an attic space, accessible only by a ladder. The attic ceiling is only about four feet in height.

Returning down the many stairs that ultimately carried us to the topmost floor, we find ourselves once again on the second floor. We move down the corridors and arrive at the main entrance in the front of the house. Crossing through the mosaic-tiled foyer and stepping over the threshold, we are now standing outside of the home. Here, many notice two distinct grotesques carved into the stone, flanking the doorway. Rumor has it that having these faces are Mrs. Tiedemann's way of dealing with the grief of losing her precious children in infancy. It's fairly safe to say that this isn't the case. Many homes of this era are most noted for their playful exterior features. The reason that this is not commonly found on other homes in the area is that few could afford such amenities.

Close inspection of the sandstone lintel directly above the main doorway reveals another feature that is easily overlooked. Placed on the keystone we see that Mr. Tiedemann's initials have been engraved, just a simple reminder of who it was who first owned this house.

Just around the left-hand side of the front steps, an engraving can be seen declaring the names of the designers, Cudell & Richardson, Architects.

Another impressive feature is the many wonderful wrought-iron balconies. It's a good likelihood that these were hand crafted by Hannes Tiedemann's blacksmith friend and co-inventor of the wrecking apparatus, Bernard McGroder. We also notice that a large ornamental finial caps off the peak of the tower. This, too, is likely built by Mr. McGroder.

Walking around to the side entrance and to our waiting carriage, we can get a better look at the porte-cochère. We see right away that it is quite unlike most others. Instead of having pillars to support it, as is commonplace, we see that it's free-standing and is supported by wooden cornices that are mounted to the side of the house.

Over the years, many have wondered where the sandstone to erect this house was quarried. Sadly, no definite record can be located, though there's one clue left behind. Cudell & Richardson would've been consistent in purchasing its building materials from the same suppliers. It's known that St.

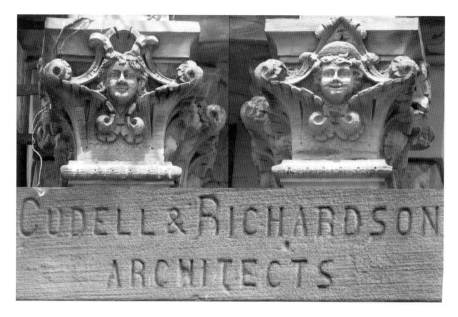

Grotesques above the front door with a stone on the west face of Franklin Castle bearing the names Cudell & Richardson—Architects. *Photo by William G. Krejci.*

Stephen's Church on West 54th Street and Courtland Avenue, one of Cudell & Richardson's sacred landmarks, was erected using Amherst sandstone. The firm likely would've used the same for this project.

Just after the completion of the Franklin Castle, the original Wolverton carriage house, located on the northwest corner of the property, was demolished. A new, two-story carriage house with a sandstone façade to match the new home was erected on the site, but this time, it was built at the northeast corner. The lower level housed the horse, buggy and straw and hay, while the upper floor was occupied by Mr. Tiedemann's coachman, John Mueller.

Hannes Tiedemann's personal fortunes soared to an incredible amount, and this was reflected by the construction of his houses in Cleveland and East Rockport. Living in the city wouldn't have been as enjoyable as being out at the country estate. It was a necessity though, as it was closer to his and his son's places of employment and to his daughter's school, located just one block from the Franklin Castle on Kentucky Street. To make life in the city more enjoyable, he spared little expense in making that house a place that would rival any other the neighborhood offered.

It still does today.

7

HEYDAY

When the Tiedemann family moved into their new Franklin Avenue house, they tried as best as they could to get on with their lives and put the grief of losing Emma and Mr. Tiedemann's mother behind them. Dora Tiedemann was hit especially hard by the passing of her sister. The two girls would've confided much in each other, and a sibling like that could never be replaced. Dora would, however, be blessed with the arrival of a new friend around this time. Moving into the house just to the east, at 279 Franklin Avenue, was a man named Frank Weischel, a local pharmacist. He had a family that included a daughter, who was Dora's age, named Frances. Dora and Frances became lifelong friends.

On April 6, 1882, a twenty-three-year-old man named Heinrich Bühning departed a vessel in New York Harbor and from there boarded a train for Cleveland. Bühning had been invited to come to the United States by Hannes Tiedemann to work in his house. Hannes enjoyed being surrounded by other Germans, as their presence evoked fond memories of home. Bühning was very mechanically inclined, and Hannes Tiedemann felt that he could use someone of his skill at both the Franklin Avenue residence and the one in East Rockport. Heinrich became the Tiedemanns' gardener and all-around handyman. Both properties were equipped with natural gas wells, and these needed regular maintenance. Heinrich Bühning was just the person for the job. After arriving at the Franklin Avenue house, he moved into the bedroom located in the servants' quarters on the first floor. Louise Pollitz, meanwhile, occupied the guest bedroom on the third.

On January 10, 1883, Hannes Tiedemann requested and was granted a voluntary withdrawal from the Masonic order. This allowed him to pursue other activities.

Shortly after, Mr. Tiedemann decided that some extra help was needed around the house. With that decision came the arrival of yet another individual from Germany, a seventeen-year-old girl named Anna M. Juergens. Her duties included cooking and cleaning. Anna was housed in the fourth-floor bedroom.

The year 1883 saw some major changes in the life of Hannes Tiedemann. First and foremost was his decision to take the money he made from his real estate investments, as well as what he had accrued from the sale of his part in the Weideman Company, and became involved in the banking industry in Cleveland. This began in the spring of that year with his appointment to the board of directors of the West Side Banking Company. He'd follow this up on May 8 by playing a major role in the formation of the Savings and Trust Company at 42 and 44 Euclid Avenue and would become its vice president. Joining Hannes in this venture was his longtime friend John C. Weideman, who aside from having recently served as Cleveland's police commissioner also served on the board of directors of this bank.

Thirteen days later, Hannes Tiedemann joined the board of directors of the Cleveland National Bank, serving as vice president there as well. Throughout all of this, he never spread himself too thin, and by becoming one of Cleveland's foremost financiers, Hannes Tiedemann's fortunes soared.

Just around this time, a twenty-three-year-old man named Edward Johannes Louis Wiebenson first arrived in Cleveland. Edward Wiebenson was born in Hemmingstedt, Holstein, Prussia, on August 19, 1859, to parents Jakob and Anna Reimers Wiebenson. In 1865, he traveled with his parents and younger sister, Amanda, to the United States, settling in Davenport, Iowa, a popular destination among many German immigrants.

Edward was educated in Davenport and studied in Germany between 1874 and 1876, after which he went to Traer, Iowa, to work as a drugstore clerk. After this, he moved to Chicago and took an apprenticeship with another drugstore and enrolled in chemistry courses at Rush Medical College. Upon completion, he returned to Iowa to open his own drugstore in Gladbrook. After a short time, Edward's health began to fail. He was forced to sell his store and return to Davenport.

As Edward's health improved, his father suggested he take a trip to Cleveland and stay for a time with a family friend from the old country,

An undated postcard for the United Banking and Savings Company, formerly the West Side Banking Company, where Hannes Tiedemann served as president for twenty years. *Collection of William G. Krejci.*

Hannes Tiedemann. He took his father's advice and arrived in Cleveland in the spring of 1883. Edward seemed at once interested in the banking industry, and Hannes was more than happy to mentor him. Enamored by what he'd learned in Cleveland, Edward Wiebenson returned west, settled in Dodge City, Kansas, and there helped organize a bank.

Edward, as it turned out, found another interest besides banking in Cleveland. That interest was in Hannes and Louise Tiedemann's twelve-year-old daughter, Dora. The two took up a friendship almost at once and continued to write to each other over the next few years.

The third great event in Hannes's life that year occurred on August 15, 1883, when a man named John Jungclas, a friend and neighbor of Gaston and Catharina Allen, passed away. Jungclas was survived by a widow named

Edward Johannes Louis Wiebenson with his sister Amanda, late 1860s. *Courtesy of Dora L. Wiebenson.*

Josephina, who purchased a portion of Gaston Allen's plot at Monroe Street Cemetery for John's burial.

Shortly after, Josephina Jungclas realized she might want to be buried beside her husband. The only problem was that the spot beside him was already taken. Wilhelmine, Ernst and Albert Tiedemann had been buried there when their lives were tragically cut short at early ages. Seeing how

Left: Jungclas family marker at Monroe Street Cemetery. *Photo by William G. Krejci.*

Right: Edward Johannes Louis Wiebenson, circa 1890. *Courtesy of Dora L. Wiebenson.*

Hannes Tiedemann had purchased a family plot at Riverside Cemetery, a request was put forth, and Hannes granted Mrs. Jungclas's wish. She would be buried beside her husband.

On August 29, 1883, the remains of the three infant children of Hannes and Louise Tiedemann were exhumed and reburied at Riverside Cemetery in a section behind the family monument. A small concrete planter box was placed on the site marking the location of their tiny graves, and their names were added to the back of the large marble obelisk that graces the plot. Now the entire family could take their repose together.

Interestingly enough, it was this event that spawned many of the stories that paint Hannes Tiedemann as a monstrous human being. Most who have done research on the Franklin Castle seem to end up at some point at Riverside Cemetery and find themselves going through the Tiedemann family burial records. It's when they see that three infant children were all buried on the same day that thoughts of them dying by some sinister means first come to mind. Most of these speculations accuse Hannes Tiedemann of foul play. In fact, it was an act of kindness that brought about this reburial. Hannes just wanted to reunite his family and allow a widow the right to be interred beside her beloved husband.

In 1884, Hannes's son, August, decided to leave his position at the Weideman Company to take a job as a clerk with the Ohio Varnish and Oil Company. He remained there for a year before entering the same field as his

Marker for the infant Tiedemann children at Riverside Cemetery. *Photo by William G. Krejci.*

father. In early 1885, August Tiedemann became a teller at the Savings and Trust Company on Euclid Avenue.

November 12, 1885, saw the arrival of a blond-haired and mustachioed thirty-year-old man named Ludwig Tiedemann to New York. Ludwig, a merchant by trade, was born in 1855 to parents Heinrich Tiedemann and Anna Hass and was raised in Hannes Tiedemann's home village of Süderau. Within the month, Ludwig Tiedemann was living in a boardinghouse on Academy Street in Cleveland. Unbeknownst to him, his distant relative Hannes also resided in Cleveland and had for many years. Had Ludwig known this, he'd certainly have looked up his cousin upon arrival. As it was, he hadn't.

Tragically, Ludwig Tiedemann went out on the night of Saturday, January 9, 1886, and got caught in a severe snowstorm. Being new to the

area and knowing limited English, Ludwig lost his way in the storm and was missing for more than four days. When he was finally located, he was brought to the Cleveland City Infirmary. Unfortunately, he'd suffered such a severe case of frostbite that his feet had to be amputated. Ludwig remained at the infirmary for the next few months and there contracted meningitis. He died on July 6, 1886, at the age of thirty-one. Not knowing what to do with the remains, a doctor at the infirmary took a chance and contacted Hannes Tiedemann. Tiedemann was surprised to discover that a relative of his had been in Cleveland and hadn't contacted him. At this, he claimed the remains and had them buried two days later in his family plot at Riverside Cemetery. There's no epitaph to tell us anything about him, only a small limestone marker with the name "Ludwig" engraved on it. Today, the stone is extremely worn and almost completely illegible.

The day after his burial, a letter was received at the infirmary that was addressed to Ludwig from his parents. This letter was passed along to Hannes Tiedemann, who replied, informing Heinrich and Anna of their son's death.

By late 1886, one of Hannes Tiedemann's financial ventures, the West Side Banking Company, was doing exceedingly well. Ten years later, it would be reformed into the United Banking and Savings Company. In early 1887, Hannes was named president, a position he held for the next twenty years.

In August 1886, a group of west side German women proposed an idea for building a home for aged Germans. Starting out with only a few hundred dollars to spend, this group sought backing from some of Cleveland's more well-off German families. Financial contributors to the *Altenheim* included Hannes Tiedemann, John C. Weideman. Charles Rauch, Louis Schlather, brewers Isaac Leisy and George V. Muth, John Meckes and many others.

The faded headstone of Ludwig Tiedemann at Riverside Cemetery. *Photo by William G. Krejci.*

Eventually, a home was erected at 7719 Detroit Avenue, with Frank Cuddell as the architect. Construction began in September 1891 and was concluded a year later. The chairman of the building committee was none other than Hannes Tiedemann.

February 1888 saw the return of Edward Wiebenson, who moved into a house just a few blocks east of the Tiedemanns. He'd disposed of his interests in his banking venture in Dodge City, Kansas, to accept a position as a bank teller, working alongside August Tiedemann and under the direction of Hannes. He'd written to Dora many times over the past five years, and now the two were able to see each other more often. A romance was blossoming between them, and on the twenty-fifth of that month, the two were engaged. They kept this a secret, of course, as Dora was only sixteen and Edward twenty-eight.

Love had struck the Tiedemanns' servants as well. Heinrich Bühning and Anna Juergens had grown close over the past few years and formed a deep attachment to each other. They were wed that spring.

August Tiedemann was also finding love. He'd been courting a young woman named Ella. Helena "Ella" Elizabeth Rauch was born in Cleveland on June 4, 1868, to parents Charles and Mary Anna Strebel Rauch. Ella's father, Charles Rauch, was the son of Jacob Rauch, a co-founder of what would become the Rauch and Lang Carriage Company. Ella's mother, Mary, was a daughter of Bavarian immigrants Johann and Magdelena Christophel Strebel. The Christophels were a very old family dating as far back in the Netherlands as 1642.

Ella was born a child of privilege, in the same social class as August. They attended school together on Kentucky Street, and it's likely that Ella was a friend of Emma and Dora Tiedemann. The courtship went on for some time, and a happy engagement soon followed.

Around this time came the arrival of two men, Henry Elert and Louise Pollitz's youngest brother, Adolph. Both came to Cleveland in search of work and were set up with decent jobs by Hannes as clerks at the Weideman Company. They were also welcomed into the Franklin Avenue house, occupying the bedroom on the second floor across from August.

August and Ella were married on June 20, 1889, at Ella's parents' house, with only the most intimate friends and relatives present. Reverend William Angelberger, pastor of the United German Evangelical Protestant Church at Bridge Avenue and Kentucky Street, officiated. Following the wedding, they took their honeymoon in Europe and returned to the United States aboard the *Augusta Victoria* on October 12. Upon reaching Cleveland, they

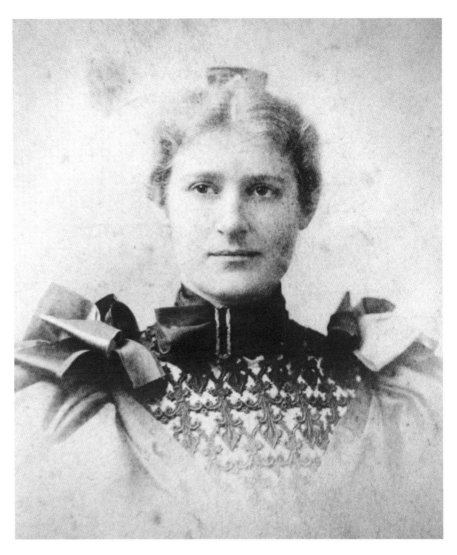

Ella Rauch Tiedemann, circa 1888. *Courtesy of Dora L. Wiebenson.*

moved in with Ella's parents. August left his job at the bank to take a position as a clerk at the Rauch and Lang Carriage Company.

In 1890 came the announcement from Dora Tiedemann that she and Edward Wiebenson were also to marry. Word of the happy occasion spread quickly, and even Frances Weischel, Dora's longtime friend—who had moved to Texas—was filled with joy for the happy couple. Upon receiving word of the engagement, Frances wrote a letter of congratulations to Dora.

On June 28, 1890, while out at the Tiedemanns' country estate of Steinburg in East Rockport, now being referred to as the Hamlet of Lakewood, Dora replied with a letter addressed to Frances:

My Dear Frances:

If you get a real cross letter, don't be surprised, because I say a certain room smells of camphor balls & Mama says it does not—so I am mad—foolish isn't it. First of all I must thank you for your kind congratulations for both birthday and engagement. I should have acknowledged your letter sooner but it was all a pair of pillow sham's fault—they were so much work. Frances, Ed & I will not marry until my next birthday when I am 20. It was in Feb. 1888 that I was engaged to Ed, when I was still 16 and still went to school. Of course we kept it secret until now. Papa & Mama are very much pleased with my choice & there is a happy future before me. Oh I have all my underwear done & pillowcases & am now going to embroider initials in table linen. Of course it is a great deal of enjoyment to get things ready for keeping house your self. August & Ella are going to start housekeeping this fall. Wasn't it sad about Mrs. Karl Schmidt's death? How very sorry I am for the girls. Elizabeth did not cry for several days & was sick in bed when her mother was brought to the cemetery. The oldest son did not arrive until after his mother was buried.

Tomorrow some of the gentlemen are going to rent buckboards & go to the "Entre Nous" Club out to Silverthorns or Wishmeyers. The nine O'clock train has just passed & I must go & fix up a little down stairs.

My regards to all.

Answer soon—Your friend Dora

Late that December, a blessing came into the family in the form of a little boy born to August and Ella Tiedemann. They named him Carl Hans. Like his father, little Carl had blue eyes but dark brown hair and the delicate facial features of his mother.

Dora continued to correspond with Frances Weichsel in Texas. Just before her wedding, Dora wrote another letter.

My dear Frances:

Received your kind letter and I know you will be very much surprised at my hasty reply. But I just feel like writing so I had better make use of this

most excelling spell. I saw Agnes day before yesterday & told her that you had said that you had had experience to back you. Oh Frances do tell me some of your experiences. I am very much interested you know, as much as you are about me surely. Hope it wasn't sad that you rejected him & he committed suicide. Lou said you wanted to know if Papa did any kicking. Oh no he was very much pleased so was Mama & everybody. I suppose you know Ed & I corresponded together since I was 12 years old & we kept it up right along. They all knew it at home. What else could my dear Papa expect but to hear the grand news sometime that we were engaged. At any rate Frances I look forward to a happy future & I have found all in Ed that you spoke of in that letter of advice. The only doubt is about myself. Oh Frances I am terribly stubborn. I never rest until I have had my will. But I think some people have altogether a different influence over one, don't you? When I was first engaged, I was walking with August one evening. He did not know anything about it and I told him then & he answered "Who said so?" He wouldn't believe it.

I have quite a number of things I have saved up all these years. Mama knit me a lovely bed-spread & now we are crocheting one which will be very pretty. I can't well decide what colors I want my bed-room and the spare-room yet. In fact, I think there is plenty of time, we have no idea where we will live yet. August and Ella will commence tomorrow to build right next to Charlie Wieber on Detroit St. Mrs. Charlie Wieber looks rather suspicious. Every little while, a laughable remark will be made that is when the married women are not around.

We went out to Rocky River last Tuesday. Schlaters are building a new house on their place. Mrs. Schlater had been dangerously ill but is slowly improving now. Rosie & Emilia have gone up north to the mountains for their health, you know Rosie is consumptive. Anna got a diamond necklace for her birthday, 11 stones. Leisys are building an enormous large house of red stone next to their old one. Mr. Otto Leisy and his wife will live in the old one. Went to call on Tonie Schmidt the other day, she is the same as ever.

So you are coming to Cleveland, that will be fine. I wish we were in town though then. Will you stay a little with me then or will you wait till Carl Krause comes back from Europe & be entirely occupied there? You better look out for some of the girls in Cleveland though because they are dead gone on him. In a few weeks probably I shall go to Defiance to see my cousins. Hope you won't arrive while I am gone.

Imagine Detroit St. is going to be paved to the west end of Cleveland & the streetcar will also go out that far. We have gas-light along Lake Ave.

now. I tell you it's improving. Now I don't know any news to tell you but that Louise [Pollitz] *is practicing exercises very diligently. I have given it up as a bad job. Mama, August & Ella are outdoors in the heat somewhere. August is sick. Again Mama hopes your mother has not forgotten about writing. We send love to you all.*

Ever your friend Dora

On May 23, 1891, Dora Louise Tiedemann was married to Edward Wiebenson. The ceremony was held at Steinburg in Lakewood with the Reverend John H. Niemann, pastor of Trinity Lutheran Church on Jersey Street, officiating.

Following their wedding, Edward and Dora moved into a home on McLean Street. By now, August and Ella had moved into a grand home on Detroit Avenue, where they remained until 1900. For Edward, along with a new married life came a promotion. He was made the secretary and treasurer of the United Banking and Savings Company.

Heinrich and Anna Bühning continued to live at the Franklin Street house, where they also started a family. Three daughters were born at this house: Viola, Alvina and Ida. The three girls shared the guest bedroom on the fourth floor.

The year 1892 saw the addition of two more children to the Tiedemann and Wiebenson families. With gray eyes to match his mother's, Herbert August Tiedemann was born on October 15. Edward Ralph Wiebenson was born on December 29, two years to the day after his elder cousin Carl. Edward was Dora and Edward's first child. Herbert was August and Ella's last.

Also in 1892, August left his job with Rauch and Lang to take a position as the secretary and treasurer of the Phoenix Brewing Company.

Toward the end of 1894, Louise Tiedemann began to experience pains in her abdomen. As the months wore on, the pain worsened so that by the beginning of 1895, she was in bed and suffering from what Dr. J.H. Lueke, the new family physician, classified as a liver complaint.

At 1:10 p.m. on Thursday, March 28, 1895, Louise Höck Tiedemann passed away at the age of fifty-seven. Funeral arrangements were made with undertaker E.H. Saxon to have Louise buried out of her home on Franklin Avenue. Louise's casket was set in the front parlor on the second floor, and at 3:00 p.m. on Sunday, March 31, the funeral service was held. From there, the pallbearers carried her casket down the front steps to the waiting hearse and

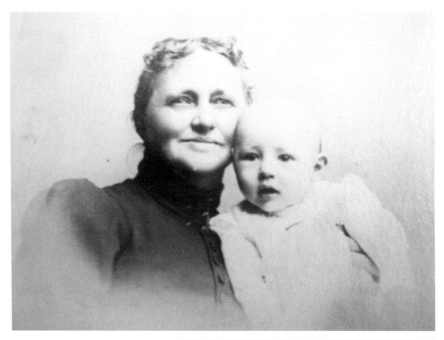

Above: Louise Höck Tiedemann with grandson Edward Ralph Wiebenson. *Courtesy of Dora L. Wiebenson.*

Right: *Left to right*: Carl Hans Tiedemann, Edward Ralph Wiebenson and Herbert August Tiedemann. *Courtesy of Dora L. Wiebenson.*

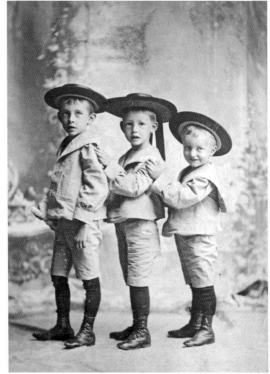

the mourners processed to Riverside Cemetery, where Louise was interred beside her daughter Emma.

Following the death of Louise, Hannes was overcome with grief and did all he could to keep himself occupied with his work. Late that spring, he boarded a vessel bound for Hamburg with a man named Claus Greve, an old friend and bookkeeper at the Weideman Company. It was there in Hamburg that sixty-three-year-old Hannes became acquainted with thirty-nine-year-old Henriette Margaretha Köpcke. Born on January 9, 1856, she was the daughter of Peter Christian and Rebecka Katharina Rüsch Köpcke of Freiburg. Henriette, by most accounts, was a short woman; in actuality, she was about five feet, five inches tall, not all that short by most standards. Other accounts claim that she was a waitress. This has never been proven.

Hannes Tiedemann and Claus Greve returned to America aboard the *Normania* on August 9, 1895. The beginnings of a relationship between Hannes and Henriette were now in place.

On April 5, 1896, Easter morning, Edward and Dora Wiebenson were blessed by the arrival of twin sons Albert August and Walter Ernst Wiebenson, Albert being born first.

Two months earlier, the house next door to Hannes Tiedemann, which had previously been occupied by the Weischel family, went up for sale. The lot was divided into two separate properties, and the house on it was torn down. The west half of this lot was purchased by Hannes Tiedemann. On May 14, Hannes sold this lot to Dora and Edward Wiebenson. Two days earlier, Hannes sent a letter to the United Banking and Savings Company:

> *Mr. Wiebenson is hereby authorized to draw on my account up to four thousand dollars to pay for Labour and material in putting up a new house next East of my dwelling No. 283 Franklin Ave. and that amount is hereby donated to him if it takes that much or more to build said house.*
> *—H. Tiedemann*

While construction of their new Arts and Crafts–style home was commencing, the Wiebenson family moved into a house on Detroit Avenue in Lakewood, not very far from Dora's father's home on Lake Avenue.

Immediately following the sale to Edward and Dora, Hannes Tiedemann and his brother Claus took a train to New York, where they boarded a vessel sailing for Hamburg. Near the end of the summer, Hannes sent news home that he would be returning with a surprise. While in Germany, he and Henriette had married on June 13, 1896.

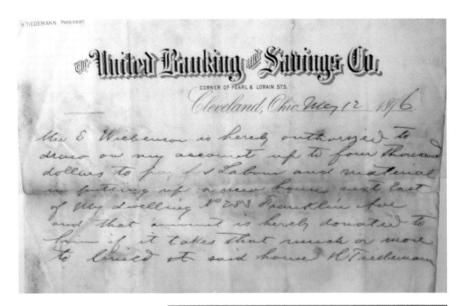

Above: Letter from Hannes
Tiedemann to the United
Banking and Savings
Company, circa 1896.
Courtesy of Dora L. Wiebenson.

Right: Hannes Tiedemann.
Courtesy of Dora L. Wiebenson.

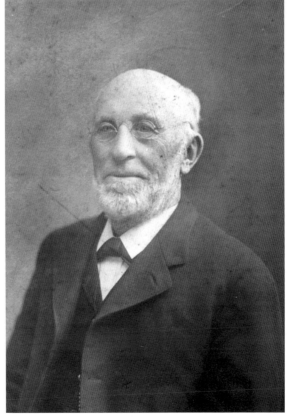

Hannes, Henriette and Claus returned from Germany on the *Normania* on August 28. Henriette took much enjoyment in watching the lake behind the Tiedemanns' Lake Avenue house. Eventually, Heinrich Bühning, who'd now Anglicized his name to Henry Buehning, built an elevated dais on the back of the property so that Henriette could sit in a chair and watch the lake as often as she'd like. Jokingly behind her back, the servants referred to this as her throne.

Sadly, before the Wiebensons moved into their new home on Franklin, one of their two newborn sons, Albert, passed away in the middle of the night of November 19 from heart disease at only seven months old. His remains were interred at Riverside Cemetery in the Tiedemann family plot. Following this, doctors took a closer look at Albert's surviving twin brother, Walter, and determined that he, too, was suffering from childhood weakness. Most assumed that he'd be lucky to live to twenty-one. In fact, he'd live to ninety-six, outliving all of his brothers.

The Wiebensons were blessed with two more births, John Jacob on December 13, 1897, and Howard Cook on May 24, 1899. By then, the family had moved into their new home on Franklin.

With the spring of 1897 coming to a close, Hannes Tiedemann realized it was no longer necessary to retain his house on Franklin Avenue. He could easily ride the streetcar from Lakewood to work in Cleveland. Also, staying on Franklin would take Henriette away from the lake she enjoyed watching for hours at a time. Whatever the case may have been, a decision was made. Just as the summer was approaching, Hannes moved himself, all his personal belongings and his servants to the house on Lake Avenue and would lock the doors to his Franklin Avenue house for the last time.

Hannes Tiedemann briefly rented out the house before ultimately selling it, thus marking the end of the first era of the house that history would come to call the Franklin Castle.

8
HANNES MOVES ON

Following the sale of his Cleveland house, Hannes and his new wife were entirely occupied at their Lake Avenue home in Lakewood but would frequently take trips to Vermilion with the Wiebensons, where Hannes's sisters Catharina and Lowiese were living with their families. The Wiebensons felt so comfortable on these visits that Edward Wiebenson ended up purchasing a cottage near the lake, where the whole family could go on weekends to get away from the city and still be close to their relations.

In 1898, Hannes and Henriette took a trip to Germany. When they returned aboard the *Pennsylvania* later that year, they were accompanied by two women who would work as servants in their house. They were twenty-two-year-old Bertha Hinze and twenty-three-year-old Tiebke Gieschen. Both spent the next few years in Tiedemann's employ, living at his house on Lake Avenue. Also employed at this time was a new coachman named Louis Gardner.

On October 5 of the following year, tragedy struck the family, as Hannes's brother Lewis died at his home in Toledo. Hannes's brother-in-law Lyman Perry Foote had passed away the previous fall. Funeral services for Lewis were held at his residence, after which he was buried at Woodlawn Cemetery in Toledo. Lewis Tiedeman was seventy-two.

In 1900, August Tiedemann moved from his home on Detroit Avenue to a rented one on Franklin only a few blocks west of his father's former residence. With a new home also came a new occupation. August Tiedemann took a job as the secretary and treasurer of the Langenau

Manufacturing Company. He and his family rented this house for a short time, the reason being that August was building an even grander house on Jennings Street.

Also occurring in 1900 was the passing of Hannes Tiedemann's longtime friend and former business partner John Christian Weideman. Weideman died from a heart attack at the New Amsterdam Apartment House on Euclid Avenue, where he resided when not staying in Lakewood. He'd been married twice and became one of the most prominent grocers in the Midwest. He'd even held public office from 1876 to 1880 as Cleveland's police commissioner, and although he'd been approached many times, he refused to run for mayor. He was laid to rest at Riverside Cemetery only a few feet away from Lyman Perry Foote. John Christian Weideman was seventy-one.

Just before the holiday season of 1900, the Tiedemanns gained an addition to their Lake Avenue residence. This came with the arrival of Henriette's fifteen-year-old nephew, Harry Peter Detlef Kern. The following year, his uncle Hannes employed him as a clerk at the United Banking and Savings Company. He'd hold that position for about a year, at which time he traveled back to Germany. Upon his return to Cleveland, he was moved to the position of bookkeeper.

That Christmas 1900, Dora wrote again to her friend Frances, telling her about their holidays spent in Ohio:

My dear Frances,

It was so kind of you to write for Christmas. I was not quite so thoughtful. You are always so good in excusing me and know you will do so again. No doubt you enjoyed your Christmas very much with your mother and Amy there. Ours was pleasant of course. Christmas vacation is quite a noisy time for us. The children jangle more than usual as they all want the same thing at the same time. The graphophone also gives its share of entertainment which the children enjoy immensely. Nevertheless, they are four dear boys and give us a great deal of pleasure and when it gets too much for me, I get in a room and sleep it off. I enjoyed my little visit with your mother very much before she left for Texas. I often think of her, how kind she was to me as a girl and let me take my dinners with you all, when she had such a family to look after. I still always use the napkin ring she gave me once. Christmas with my brother's family and ours were at my father's on Lake Avenue. Henriette is a very kind good woman but

everything is so different than it was formerly. Mr. Wiebenson joins me in thanking you for your kind wishes and we most heartily wish you a very Happy New Year.

I am ever your sincere friend Dora L. Wiebenson

Many decades later, Dora and Edward Wiebenson's son Walter recounted his childhood spent growing up in Cleveland. His account is quite lengthy and fortunately very detailed. He remembered quite vividly many of the events that occurred in his family during that time, and it's because of this we can get an insight into what life was life back in those days.

In these accounts, Walter recalled spending many summers with his family at Ocean City, New Jersey, and the months spent at a convent near Youngstown, where one of his mother's friends was living as a nun. This occurred around 1902, when his parents were on vacation in Europe. Mr. and Mrs. Wiebenson were fond of traveling, though bringing their entire family would have been too much to handle for such lengthy trips, especially with the boys being so young. Dora wrote to Frances after her return to the United States, telling her about their vacation:

My dear Frances,

Yesterday was your birthday and again I did not write to you in time. I congratulate you most heartily. We returned about the 21ˢᵗ of September and did not have a very pleasant passage over. Yet were fortunate not to strike a severe storm. We were gone in all four months which seems a good long time. The children were so well taken care of by the nuns but you ought to have heard them when they came home. Talk—I never thought they would stop and Catholic as you please. Next morning they built an altar in their bedroom so they could pray but they are gradually getting normal again. We enjoyed our trip very much. Two months we stayed at Neuenahr not far from Bonn and the one month traveled. I was real glad when it was at an end, it did tire me so. I expect you enjoyed your mother's visit ever so much. I shall call on her soon. I keep more help now and can get away better. Our house is so miserably full. All the boys are away at lunch which is a great relief. Edward will be in high school in two years if he does well. He is almost as tall as I am. It does not seem long ago that we were little girls going down Pearl Street together. What a good time we used to have. I hope to hear from you soon and also that you will

visit us some day in the near future. I am with kindest regards to you and your husband ever your sincere friend,

Dora L. Wiebenson

P.S. Just read over your last letter and thank you for your kind invitation to visit you. Who knows perhaps some day when I can eat like other respectable people I might take a run down to visit you. Last winter when I mentioned it to my husband he said why yes if you like. In fact, I get everything I like. Some day I am afraid I shall be dreadfully spoiled. Miss Payn [referring to Agnes Payn, Dora's nurse] *and I were to Quebec this summer and from there to Poland Springs in Maine. It was beautiful there but did not enjoy it as well as I might have because I was not feeling comfortable all the time. Am sorry you lost your mother-in-law. Yes Frances it is very hard for us to lose our friends as we grow older we feel it more and more. Give my love to your husband and write soon with love D.*

Walter Wiebenson recalled his father purchasing a two-cylinder car called the Gale, of which he believed there were only six ever made. The farthest his family ever got with that car was about fifty miles, likely to Vermilion, as they always had to change the tires from blowouts. The car never really did more than twenty miles per hour and was so noisy that people would come out to the road a block ahead of them just to see the vehicle. Automobiles were still something of a rarity back then and were really something to see. If they would encounter a horse along the way, it would shy and jump about, as it was not used to seeing such a thing. Shortly after the family sold this car, the new owner was driving it on Public Square where it backfired and blew up. Afterward, Mr. Wiebenson purchased a Rauch and Lang automobile.

Walter continued his account by remembering quite well their milkman who came every morning with his milk wagon and the same horse every time. This horse didn't need to be driven at all. He knew the route so well that all the milkman needed to do was tell him to go, and he would move to the next stop.

He also remembered the iceman who came about twice a week. Families hung a piece of cardboard on the front of their house with a weight amount written in the corner, telling the iceman how much ice was needed. Here he'd carve off a piece of ice, lift it with his tongs, place it on his shoulder and carry it in through the back door, where it was placed in an ice chest. There were no electric refrigerators in those days. During the wintertime, Walter

Left to right: Walter, Edward and John Wiebenson playing in front of their new home on Franklin. *Courtesy of Dora L. Wiebenson.*

and his brothers would hitch their sleds to the back of the ice wagon and get a free ride down the street, after which they'd try to hitch a ride back by hooking up to another wagon.

Another fond memory from Walter's childhood was a pony that he owned named Peter Pan. This pony was kept in the carriage house behind the Wiebenson home.

Located just across the street from the Wiebensons' house on Franklin, as well as the former Tiedemann house, was Hemler's grocery store. Here the family purchased all of their groceries, as it was convenient for them to simply walk across the street and do their shopping.

A sad and unfortunate fact throughout all of this was that Dora Wiebenson, like her sister Emma, had now developed diabetes. When Dora wrote to Frances in her last letter and mentioned someday being able to eat like other

respectable people, she was referring to how diabetics needed to follow strict diets to maintain their health. At the time, this was about the only treatment available, though some spas in Germany claimed to also help. Just before taking such a trip to Germany in 1904, Dora wrote once again to Frances.

My dear Frances,

You are truly a sincere friend to remember me so kindly when I did not even write to your birthday. I thought of you just the same Frances and fully intended writing but have treated everybody the same. As a rule when I get through with my children I am quite tired and when they are in it is almost impossible to write nor read. They are a very lively set and enjoy quarreling immensely. I intended on calling on Theresa ever since she married and tried to see your mother yesterday but she had not arrived at her summer home but saw Miss Sharper—she is just the same. I have made hardly any calls this winter and those were in the immediate neighborhood. My health is better than it has been and hope to be entirely cured at Neuenahr near Coblenz.

Left to right: John, Howard, Edward and Walter Wiebenson. *Courtesy of Dora L. Wiebenson.*

They seem to make a specialty of diabetes there. My trouble is not painful at all excepting dull pains in my legs. I am not fond of going out as talking tires me as much as anything. But am very much improved since last fall. Dr. Lueke, Mrs. Lueke, Elsa & Martha are going on the same boat and we have our rooms adjoining, so I anticipate a very pleasant voyage. I shall try to write you from Bad Neuenahr, Germany and hope to hear from you also. I expect to spend all of July there. We leave with the Noordam *on May 31st at 10 o'clock. After July I hope to travel through Switzerland and see the larger cities of Germany. Edward* [her son] *& my niece* [Lillie Wieland] *will accompany me. My niece is from Iowa, 19 years old and a very lovely girl. She is very much delighted. It is rather hard to leave Mr. Wiebenson and the 3 little ones. Mr. W will be at the house and the boys at a convent near Youngstown. They will be on a farm and all alone with the sisters so I guess they will be in good company and no harm will come to them. It is better to leave them now a little while than a little later for good. I think I shall be very busy this week getting the trunks packed and the house ready. I have been writing so much about my own affairs that I have not even told you I am so glad that you are perfectly well now, and I hope you will continue so, as I think you have had your share. Again I thank you for your kind letter. Remember me kindly to your husband and with love to you I remain.*

Truly your friend Dora L. Wiebenson

Dora, Edward and her niece Lillie returned to the United States aboard the steamship *Deutschland* on September 22, 1904. Dora and her son Edward remained in Cleveland for a little less than a year and returned to Germany in August 1905. Joining them on this trip was Dora's nurse, Agnes Payn, and one of her other sons, Walter, who later recounted their time in Germany quite vividly. Walter, as mentioned earlier, was considered to be quite weak and not expected to live beyond his early twenties. Dora and her husband believed that by bringing Walter to Germany, he, too, might be able to receive treatment for his ailment.

The four of them sailed on a small steamship named the *Rhine*. This crossing took ten days to make before reaching its destination in Bremen. Walter remembered the voyage as being quite an experience; he befriended many of the other passengers on board. He particularly remembered a coin-operated chair in the salon that would vibrate for about ten minutes. This was supposed to stop people from having seasickness but had the opposite

effect on Walter. He was so sick after using it that he spent the next two days in his berth.

After reaching Germany, they continued on by train until reaching Neuenahr, where the spas were located. After a few months, they continued on to Frankfurt-On-Main. Walter remembered that he was enrolled in grade school there and was surprised to learn that the children were learning to speak English as early as first grade. Likewise, he, too, was learning German and picked up on it so well that eventually he was thinking in German. At first, Walter had some trouble fitting in, as he'd constantly be teased by the other students, who called him "dirty Englishman" and the like. This usually ended in a fistfight, until one day he was called into the principal's office and told to stop fighting. Things seemed to settle down after that.

Their apartment was located very close to the zoo. Walter spent many hours watching the gorilla and was amazed at how intelligent it was. Also while in Germany, Walter befriended a boy named Fritz Horning. Fritz's father was a longtime friend of Hannes Tiedemann and was in charge of a large food establishment that delivered food to various restaurants and hotels. Most likely, Hannes and Horning became friends while Hannes was living in Germany with his family during the late 1870s. Whenever the Wiebensons needed assistance, Horning was always there to help. Many years later, while Walter was serving in Europe during World War I, he often wondered if he'd run into Fritz, as they were the same age and Fritz was likely also fighting in the war—but on the other side.

Back in Cleveland, August Tiedemann and his family settled into their new home on Jennings, but for all that August had achieved in life, his health was declining. August smoked for years and lived a fast-paced lifestyle, which was catching up with him. In late 1905, August traveled to Germany, likely to the same spas in Neuenahr that his sister visited, to seek treatment for his weakening condition. Although these treatments might have helped for a short time, the effects were not lasting. While in Germany he visited his sister, spending the holidays with her and her sons.

August Tiedemann returned to the United States aboard the *Amerika*, landing in New York on February 20, 1906, where he took a train back to Cleveland and was reunited with his wife and two sons. This reunion lasted only two months.

On April 20, 1906, August Johannes Tiedemann passed away from arteriosclerosis, a condition he'd been suffering from for the past three years. The death occurred at his home on Jennings and was confirmed by W.H. Rogers, his physician. The Saxton Funeral Home made arrangements for

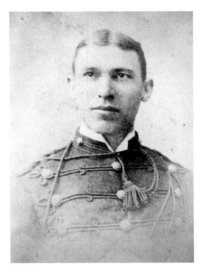

August Johannes Tiedemann, circa 1888. *Courtesy of Dora L. Wiebenson.*

the services that were held on Sunday, April 22 at 2:00 p.m. The following morning, his remains were cremated and returned to his widow. It would be thirty-five years before his ashes were interred at Riverside Cemetery. For the last few years of his life, he worked as the secretary and treasurer of the Beckman Company, a woolen manufacturer where his father, Hannes, served as director. He was also a prominent member of the Elks Lodge. August Tiedemann was forty-one.

Immediately following August's death, Dora returned to Cleveland just in time to attend her brother's funeral services. She remained for a month before going back to Germany. Hannes and Henriette accompanied her on the return trip to Frankfurt-On-Main and stayed there until August 23, when they boarded the U.S.-bound steamship *Blücher* in Hamburg.

As the holiday season of 1906 was approaching, Edward Wiebenson made plans to travel to Germany and spend Christmas with his beloved Dora and sons Edward and Walter. He'd recently been promoted to the position of vice president of the United Banking and Savings Company. In preparation for his voyage, he obtained letters from the U.S. Department of State, U.S. Senate, Cleveland police chief and Tom L. Johnson, mayor of Cleveland. All letters were addressed to any foreign parties whom Wiebenson might encounter on his travels, introducing him and asking that any assistance he might need be given to him.

Dora was anticipating the arrival of her husband, whom she'd not seen since her brother's funeral. The Christmas holiday was the perfect time for a reunion. Recent letters from Dora indicated that her health was improving. There were hopes that at the end of Mr. Wiebenson's visit, his wife and children would return home with him to Cleveland.

In Frankfurt-On-Main, Germany, while preparing for the arrival of her husband in a couple weeks, Dora thought it a fine evening to take in a show with her son Walter. Her eldest son Edward and her nurse Agnes Payn were sightseeing in Dresden. Dora and Walter went out on the evening of

December 2 and visited a theater that was located across from the railroad station. There, they took in a vaudeville-type show.

About halfway through the show, which Walter was enjoying, Dora excused herself to use the ladies' room, leaving her son in his seat while she was gone. On her way to the ladies' room, while walking down some steps, Dora tripped on her dress and fell down the flight of stairs, fracturing her hip.

Walter remained in his seat, watching the rest of the show, wondering why his mother hadn't returned. It wasn't until the show ended and the theater cleared out that two men approached him and escorted him to where his mother was waiting in an ambulance. There were no modern hospitals in that town, so Dora was taken back to their apartment. The ambulance wagon had iron wheels, and as it moved across the cobblestone road, it aggravated Dora's injury, which only added to her suffering.

Once back at their apartment, several doctors came in and did what they could, which wasn't much. Edward and Agnes were contacted in Dresden and arrived early the next day. An infection set in, and with Dora's compromised diabetic condition, there was little to be done but make her comfortable. Dora Louise Wiebenson, Hannes Tiedemann's only surviving child, died two days after her fall in Frankfurt-On-Main, Germany, not even eight months after her brother August had passed. She was thirty-five.

Not knowing what to do in a case such as this, Agnes Payn contacted Mr. Horning, who at once made contact with Mr. Wiebenson back in Cleveland and sent word of the tragedy. From there, Mr. Horning made the arrangements for Dora's body to be returned to the United States.

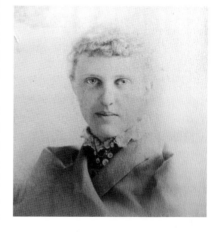

With Dora's remains stowed in a casket in the cargo hold, her sons Edward and Walter and nurse Agnes Payn boarded the *Kaiser Wilhelm II* on December 16, 1906, in Bremen and arrived in New York on December 22, where Mr. Wiebenson was waiting to meet them. They boarded a train and returned to Cleveland, where funeral services were held. Dora was buried at

Dora Louise Tiedemann Wiebenson, circa 1890. *Courtesy of Dora L. Wiebenson.*

Riverside Cemetery only a few feet north of the Tiedemanns' burial plot. Shortly after, the remains of her infant son, Albert, were removed from the Tiedemann plot and re-interred beside her.

Two items of importance occurred in the months following Dora's death. In January 1907, Hannes Tiedemann stepped down as president of the United Banking and Savings Company, at which time his son-in-law, Edward Wiebenson, succeeded him. Although no longer president, Hannes remained on the board of directors and was at his desk nearly every day. The other event that occurred came on February 5, with Hannes Tiedemann changing his last will and testament. Now that his children were deceased, amendments needed to be made. His will, in brief, stated the following:

1) That all debts and funeral expenses be first paid out of my estate.

2) Bequeath to the West Seite Frauenverien, which maintains a home for the elderly, $4,000 to be paid eighteen months after my death.

3) To my hired man Heinrich Bühning, $5,000, provided he remain in my employ until my decease.

4) $50 per annum in caring for my lot at Riverside Cemetery.

5) To my wife, Henriette M. Tiedemann, $50,000 in lieu of all claims to my estate in accordance with agreement made by her February 10, 1898.

6) To my daughter-in-law, Ella E. Tiedemann, my real estate in Lakewood purchased from Henry Beach, that it remain in the name of Tiedemann as long as any descendants of that name survive and that it continue to be called Steinburg.

7) To my son-in-law, Edward Wiebenson, my real estate in Lakewood purchased from Martha Fry.

8) 1/6 of my estate to Edward Wiebenson,

9) 1/6 of my estate to Ella E. Tiedemann,

10) 4/6 of my estate to my trust to be bequeathed to my six grandsons [followed by lengthy directions on how and when it was to be paid].

11) I nominate Edward Wiebenson, Charles Rauch and E.S. Cook executors of this my last Will and Testament.

Hannes continued on as best he could throughout that year and attended to his duties at the bank. The sudden loss of both of his children was a very hard blow, yet he remained as strong as he could in the face of such despair. By Christmas 1907, things might have looked like they were returning to normal. Nothing could be further from the truth.

Just after the holidays, Ella Rauch Tiedemann felt she needed a vacation and decided to purchase a railroad ticket that would take her on an excursion to Florida. The Collver Special ran annually and originated in Cleveland under the direction of David Jay Collver. It departed the station in Cleveland at 12:25 p.m. on Monday, January 6, 1908, and began its long trek south. The following afternoon, just shortly after 3:00 p.m., the train was located near Hiram, Georgia. They were running somewhat behind and were moving at a fast rate of speed, attempting to make up the lost time. While crossing the Copper Mine Creek trestle, the engine jumped the tracks and careened into the shallow gully. The coal tender was tossed onto the cab of the locomotive, instantly killing the engineer. Following the tender, the baggage car was tossed into the ravine followed by five Pullman cars. Nearly thirty people from Cleveland were listed as injured. Among them was Ella Tiedemann. She was treated for her injuries in Atlanta, where she remained for a couple days before returning home.

The news of the accident reached Cleveland within a day, and Hannes Tiedemann found himself in an upset condition at the near loss of his daughter-in-law. That would have been too much for him to bear. Ella Tiedemann was back in Cleveland within a few days, and that Thursday found Hannes Tiedemann at work in his office at the United Baking and Savings Company, where he first began to feel somewhat under the weather and slightly weaker than he normally did. Even at that, he continued on and was at his desk on Friday and Saturday.

After finishing work on Saturday afternoon, he returned home to Lakewood and thought it best to take it easy the rest of the evening. The following morning, on Sunday, January 19, 1908, he found it much harder to get around and likely returned to bed. At 3:15 that afternoon, his wife

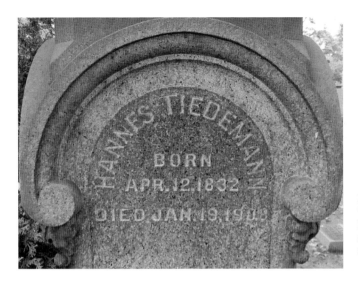

Hannes Tiedemann's headstone at Riverside Cemetery. *Photo by William G. Krejci.*

Henriette at his side, Hannes Tiedemann passed away from arteriosclerosis, the same disease that had taken the life of his son August just two years earlier. He was seventy-five.

The death of Hannes Tiedemann, while coming as a surprise, was something that his co-workers at the United Banking and Savings Company were unfortunately becoming accustomed to. Over the last year, two other bank officials had also died unexpectedly. Vice President John Meckes passed just ten months earlier, and Chairman of the Board of Directors Russell A. Brown had also recently died.

At the time of his death, Hannes Tiedemann was one of the most recognized and well-respected financiers in Cleveland. He was known for his philanthropic services to the community and his warm and inviting personality, especially toward fellow Germans. He also served on the board of trustees at Riverside Cemetery for years. His passing was mourned by many.

Funeral arrangements were made with the McGorray Funeral Home, and services were held at his house on Lake Avenue at 2:00 p.m. on Wednesday, January 22. From there, the funeral processed its way to Riverside Cemetery, where Hannes Tiedemann was interred that afternoon beside his beloved wife, Louise.

Thus concluded the life of Hannes Tiedemann.

RELATIVELY SPEAKING

Perhaps it's best to take a look back at the history of the Franklin Castle and, more specifically, the Tiedemanns. So far, we've learned about the early years of Hannes Tiedemann, his origins in Germany and what ultimately brought him to Cleveland. We've also learned about the Wolvertons, who built the first house to occupy the property.

Hannes Tiedemann began his career in Parma as a cooper's apprentice but decided to change directions and entered the grocery trade. He married and became the father of six children, three of whom died as infants. Stories told about the deaths of these children all say that they died in 1883 under mysterious circumstances. As earlier stated, this was not the case. They died from fairly common causes over a ten-year period. It was the re-interment of these children in 1883, brought about by an act of kindness, that spawned legends of foul play.

Other tales have told us that Hannes was responsible for killing a servant girl and secret lover named Rachel, as well as a niece named Karen. Neither of these people ever existed. All of Hannes Tiedemann's servants' names were given in the preceding pages, and although he had many nieces, no one was named Karen. That name will, however, appear in future events. After conducting thorough searches of the county coroner's records, the only person to die in the Franklin Castle during the Tiedemanns' tenure was Hannes's wife. His daughter Emma and two sons Albert and Ernst died in the first house on the site. Many people have speculated that Emma was insane or promiscuous and was dispatched by her father. This is completely absurd. We've read in letters written by Dora that Hannes Tiedemann

was a loving father and wasn't given to fits of rage. There should be no debate hereafter concerning the passing of Emma Tiedemann. Her cause of death was diabetes. This is reinforced by the fact that her younger sister suffered from the same affliction, which contributed to her death.

So what is the true story of the Tiedemanns and the early years of the Franklin Castle? It is the tragedy that ensued over the years. That is the true legacy of the Franklin Castle. Simply put, it is sadness. Hannes Tiedemann, though suffering through the loss of his family, still managed to become one of Cleveland's most well-respected businessmen, yet the legacy that follows him is one of accusation that blames him for murdering people, some of whom never existed.

We also know when the Franklin Castle was built, despite what's written on the transom window above the front door. We have an idea of what the house originally looked like, as well as who occupied the various rooms. After all, the people who dwelt within this house must have left something of an impression. We know also what function each room served. This would be reflected on the house in later years and contribute to the ways it's changed between then and now.

One would think that the Tiedemann's legacy of tragedy ends with the death of Hannes Tiedemann, but it doesn't. In fact, when Hannes Tiedemann passed away, his death marked the beginning of a sad chain of events that plagued the family in the months to come.

On the morning of February 20, 1908, Gaston G. Allen, the husband of Hannes's sister Catharina, passed away in his home at 1422 West 77th Street in Cleveland. Gaston was ill for ten days and finally succumbed to bronchial pneumonia. Services were held at Bigelow Lodge, after which he was buried with high Masonic honors at Monroe Street Cemetery in the same lot that once held the remains of the Tiedemanns' three infant children. A large monument was placed at the site by his fellow Masons. Gaston G. Allen was eighty-six. Catharina followed him to the grave on August 2, 1912.

On March 26, Hannes's sister Eliza Tiedemann Foote passed away. Like Gaston, she was ill for ten days, but like her brother Hannes, she died from arteriosclerosis. Funeral services were from her daughter's home in Lakewood, after which she was interred beside her husband at Riverside Cemetery.

Just one week later, on April 2, Alice Tiedemann, the nineteen-year-old granddaughter of Hannes's brother Claus, passed away and was buried at St. Joseph Cemetery on Woodland Avenue in Cleveland.

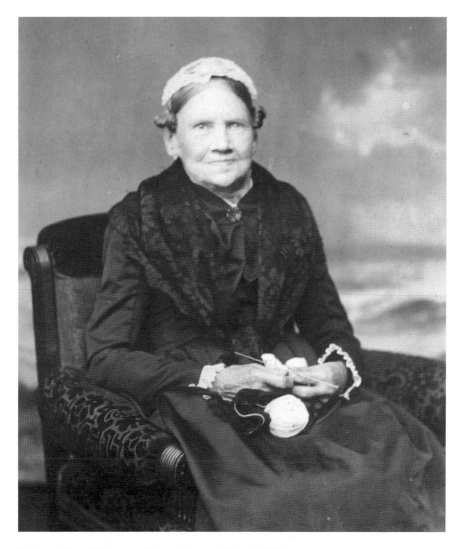

Rebecca Eliese Tiedemann Foote. *Courtesy of Dora L. Wiebenson.*

Twenty-five days later, Hannes's eldest brother, Claus, passed away. The death occurred at his family farm on Tiedeman Road in Brooklyn, Ohio. His cause of death was cerebral apoplexy, likely from a stroke. Funeral services were held at his residence, and interment was at Woodland Cemetery, located just up the road from where his granddaughter was buried only a few weeks earlier. Claus Tiedemann was eighty-five. His wife, Emielie Baumgart Tiedemann, joined him the following August.

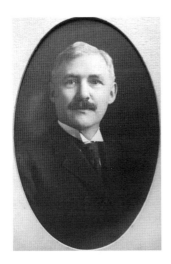

Edward Johannes Louis Wiebenson. *Courtesy of Dora L. Wiebenson.*

Then in late March 1910, Edward Wiebenson, Dora's widowed husband, began experiencing pains in his lower abdomen. He'd just returned from a trip to Jamaica, where he hoped to recover from failing health. He was taken to Lakeside Hospital, diagnosed with appendicitis and received an appendectomy. Unfortunately, an infection set in. This infection developed into pneumonia, and Edward knew he had reached the end of his days and would soon be reunited with his beloved Dora.

Lying on his deathbed, Edward Wiebenson composed two letters. The first was of a personal nature and addressed to his eldest son, Edward Ralph Wiebenson. It read as follows:

Dear Edward,

Feeling that you should be prepared for the responsibility that may soon be thrust upon you, I will jot down a few thoughts about things, others may not be informed on. Mr. Cook will hand you a few letters from mother. They refer mainly to Walter—I concur in everything in those letters—Kindness and affection is what he wants and needs.

John is very ambitious and should not be hindered, but rather less in channels that will bring out all the good there is in him, but not along selfish lines.

Walter and Howard must understand that they must look out for themselves and not allow themselves to be worked—This may be good for you also—The main thing is that you must all be careful of your health—Exercise and outdoor life as much as possible. The kindness of friends and associates will always mean much for all—You know how upright mother was—It was her influence, advice and example that helped me in my battles, and it will help you all also—Think of her in all your acts in the future and you will not do anything you will afterwards regret. I do not mean, that you should not make any mistakes—We all have, and all must err—Through errors we should learn "Here are my don'ts."

Never injure or harm the "other fellow" if it can be avoided in honour. If you have, apologize or "make good."

Don't let the "other fellow" do you, but do all the good you can in a sensible way.

Don't try to accomplish too much. Many have ruined themselves and others through overconfidence. Lasting good and success generally comes through evolution. It does not pay to be too risky.

Don't think this was intended as a sermon.

*I **do** want you boys to stick together and "stick up" for each other always no matter what happens.*

Be temperate in all things and don't do any thing that will injure your health. If any weakness should develop in any one, be kind and true and do what mother would have done were she still here—When misunderstandings occur, as they are bound to, don't let pride keep you from making full explanation and admitting an error—Don't worry! Do your duty at all times and everything will come out all right in the end.

Father

A second, shorter letter, directed to all four of his sons, read as follows:

Edward, Walter, John and Howard

Cheer up, help each other all you can, always be happy and make others happy. It will lighten the load. If the worst should happen, I want everything carried on as quietly and simply as possible.

It was mother's wish and is mine also that no monument be erected on our lot—Headstone same as mother's is all—Don't wear any mourning or put wreaths on the house or on the bank—Flowers on desk will be better than crape—Be brave, do your duty, stick together and all will be well.

Father

PS Edward I want you to be sure that all is over before you allow them to bury me.

Edward Wiebenson expired from pneumonia during the early hours of April 1, 1910. He left behind four sons; the eldest, Edward, was seventeen. The youngest, Howard, was ten. As instructed in his letter, Edward Wiebenson was buried beneath a small headstone that matched his wife's just a few feet north of the Tiedemann family plot at Riverside. Aside

from being the president of the United Banking and Savings Company, he was also vice president of the Cleveland Pneumatic Tool Company, director of the Beckman Company and Cleveland National Bank, director and treasurer of the Stark Electric Railroad and trustee of the Public Library Sinking Fund and of Riverside Cemetery. Edward Johannes Louis Wiebenson was fifty.

Following the untimely death of Mr. Wiebenson, his boys continued to reside at their home on Franklin with their cousin, Lillie Wieland, and their mother's former nurse, Agnes Payn, who was serving as their governess. Both had remained members of the household since Dora's passing. Also residing in the home were Lillie's sister, Anna Wieland, and a twenty-two-year-old domestic servant named Anna Goohs.

Edward, the eldest of the Wiebenson boys, was already attending preparatory school in Asheville, North Carolina. Also attending this school and living in the room beside him were his cousins Carl and Herbert Tiedemann. The following year, Herbert attended college at the University of Pennsylvania in Philadelphia, where he resided with his mother.

On February 27, 1911, Ella Rauch Tiedemann sold Hannes's former home on Lake Avenue in Lakewood, which had been willed to her and her children. It was Hannes's wish that the property remain in the Tiedemann family as long as an heir of that name existed, though it was not construed as listing any attachment. In short, it was only a request and not a stipulation of the will. The home was sold to Mabelle and William James Hunkin.

The Hunkins changed the name of the Lakewood estate from Steinburg to Ledgewood soon after taking possession. They remained at that address until October 1914, when they sold it to Charles Wieber, a friend and neighbor of Hannes Tiedemann and vice president of the Rauch and Lang Carriage Company. The land was divided and sold off piece by piece. The section the house sat on was sold to an inventor and rubber industrialist named Lawrence Alonzo Subers.

Subers resided at the former Tiedemann home for ten years. On December 18, 1924, he sold the property to the Cleveland Trust Company, which transferred it to the Morris Arnoff Realty Company. Ultimately, a twenty-eight-suite apartment building was planned. At this, the Tiedemann estate was razed and in its place was built the Shoreham Apartment Building. The Shoreham had a short run as far as apartments go. In 1940, it was demolished to make way for the Lakecove Apartment Building, which graces the site today. Edgewater Drive cuts across what was once the long, green yard that extended to the lake.

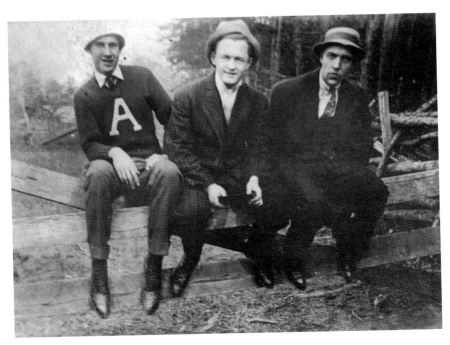

Left to right: Carl Hans Tiedemann, Herbert August Tiedemann and Edward Ralph Wiebenson at Asheville, North Carolina. *Courtesy of Dora L. Wiebenson.*

In 1914, Herbert Tiedemann and his mother took a trip to Europe. Herbert's elder brother, Carl, went on to attend Cornell University, where he learned the wool manufacturer's trade and later took over his grandfather Hannes's former position as president of the Beckman Company in Cleveland, where his father, August, had been working at the time of his passing.

After returning from Europe, Herbert married a woman named Anna "Nan" O'Boyle of Philadelphia. It's likely that he met her while attending school there. They ultimately moved to Atlantic City, New Jersey. Ella Rauch Tiedemann also found a spouse in an industrial mogul and inventor named John Tefft Clarke of Nebraska.

The four Wiebenson boys all married and had children of their own, and although they eventually lived in different parts of the country, they would stick together per their father's dying wish. Ella Rauch Tiedemann's second husband died on November 10, 1941, and was buried at Riverside Cemetery. That same day, August Tiedemann's cremated remains were also interred. Ella lived to the grand age of eighty-six, and died at her residence in Atlantic City, New Jersey, on May 5, 1955.

Herbert Tiedemann and Nan O'Boyle were divorced during the early 1920s. Soon after, Herbert remarried. His second wife was Katherine Cartmell, who met Herbert while living in Asheville.

Herbert's second marriage was also short-lived. By 1933, the couple had begun divorce proceeding and separated that May. Herbert moved to Florida, but the divorce was never finalized. Herbert August Tiedemann died in St. Petersburg, Florida, on March 7, 1934, from myocardial insufficiency. Like his father, he was forty-one at the time of his death. Of Hannes Tiedemann's six grandsons, Herbert was the only one who didn't have children.

Herbert's brother Carl remained in the Cleveland area, living in Shaker Heights. Sadly, the stock market crash of 1929 forced the Beckman Company into liquidation. Even though his company was being sold off, Carl was assured a place in the industry and would always have a position in that field.

On the evening of December 16, 1929, while driving home from work across the old Clark-Pershing Avenue Bridge, Carl was involved in a minor auto accident in which he struck two oncoming vehicles. After apologizing to the other drivers, giving them his home address and assuring them that their damages would be taken care of, Carl Tiedemann walked to the side of the bridge, placed his hat on the hood of his car, waved briefly and leaped over the side. His body was discovered on the railroad tracks near the guard shack of the steel mill below. His cousin, Howard Wiebenson, identified him at the coroner's office. The site of this tragedy was only a few blocks from the home that Carl had grown up in on Jennings Avenue. Funeral services were held on December 19, followed by interment at Riverside Cemetery. He was survived by his wife, May Glenn Tiedemann, and two children, Frances, age eight, and Carl Hans Tiedemann II, age three.

It was debated whether or not his death was a suicide. The day after the incident, an associate of Carl's, Bruno Uhl, released a statement giving the opinion that the reason for Carl jumping was that he was disoriented from a severe blow to the head that occurred during the accident and he wasn't aware of what he was doing. According to friends, he'd been quite happy as of late and had a wonderful home life with a loving family. No explanation could ever be determined as to why he jumped from that bridge. His mother returned to Cleveland many times over the years and, on many occasions, petitioned to have Carl's cause of death changed, though she never succeeded. Even today, his death is still ruled a suicide. Carl Hans Tiedemann was thirty-eight.

So there it is. Legends say that Hannes Tiedemann died from a stoke while walking in the park, yet we know that he died at his home in Lakewood and

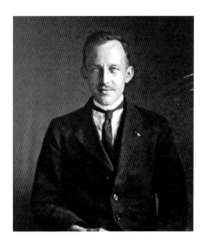

Carl Hans Tiedemann, circa 1918.
Courtesy of the National Archives.

not from a stroke. It's also said that his marriage to his second wife, Henriette, ended in divorce and she inherited nothing. This is also untrue. She inherited $50,000, provided she make no claim against his estate, which she didn't.

Henriette remained in the Cleveland area after Hannes's death. In 1909, she moved into an apartment at 4405 Franklin Avenue—just across from the Franklin Castle—but, more importantly, across from the Wiebenson house, where her step-grandchildren lived. She resided for a time with a friend named Ida Stuhr but ultimately moved to an apartment at 11119 Clifton Boulevard in 1926. This is her last known address. She likely returned to Germany and lived out her days in Hamburg. If this is true, it may also be unfortunate. Henriette was financially independent, thanks to her husband, and Germany was experiencing halcyon times. That would all change with World War II. In fact, tens of thousands of civilians in Hamburg were killed or wounded during Allied bombing missions. There is a grave in Hamburg's Ohlsdorf Cemetery that contains one such bombing victim, who died in 1945. Her name is Henriette Tiedemann, but there are others with that name, so it might not be her.

The legend of Hannes Tiedemann says he outlived every member of his family. While it's true he outlived his first wife and all six of his children, he was survived by six grandsons, and all but one had children. Hannes Tiedemann has many living descendants.

THE WIDOW AND THE DOCTOR

The next part of the rich and colorful history of the Franklin Castle involves the various occupants and owners who followed the Tiedemann family. They are a unique fellowship, which begins with a young lady named Louise Strangmann.

In 1870, Louise came to Alexandria, Virginia, to live with her uncle, Robert Portner, who had immigrated in 1853 and owned the Robert Portner Brewing Company. The following year, he hired a young German brewmaster named Paul Mühlhaüser.

By 1872, Paul Mühlhaüser and Louise Strangmann had wed and occupied a house on the brewery grounds. A few years later, Louise's younger brother, Carl Augustus Strangmann Jr., came to Alexandria and worked as a shipping and office clerk at Portner's brewery.

Paul and Louise Mühlhaüser's love resulted in the birth of baby Ernst on September 23, 1876. Shortly thereafter, Paul took his young family to Baltimore, Maryland, where he and a man named Franz Thau partnered in a business venture named the Thau & Mühlhaüser Crystal Springs Brewery. In 1881, it became the Adler & Mühlhaüser Enterprise Brewery, after Thau sold his interests to a man named Elias E. Adler.

Paul and Louise's family continued to grow, adding daughter Anna on October 18, 1880, and son Paul Jr. on November 5, 1882.

By now, Robert Portner wanted Paul back at the Portner brewery, because big things were about to happen. The Mühlhaüser family returned to Alexandria, and Paul resumed his position of brewmaster

and superintendent. He was also promoted to vice president.

In May 1883, the Robert Portner Brewing Company was incorporated, and Paul received stock in the company, as did Carl Strangmann, who had been promoted to facility manager two years earlier.

Two more Mühlhaüser children joined the family circle: Carl in February 1885 and Otto in April 1886. Another child was expected in August 1890, but forty-year-old Paul Mühlhaüser was not there to greet him. In early August, Paul was admitted to the Alexandria Infirmary with diphtheria and died on August 21, 1890. A few days later, Louise gave birth to their sixth and final child, Albert.

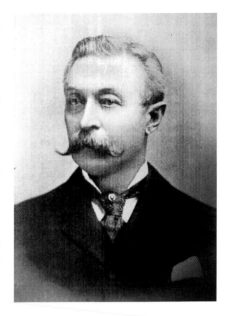

Robert Portner, early 1890s. *From* One Hundred Years of Brewing, *1903.*

The Portner Brewery was struggling by the mid-1890s, so in January 1895, Carl Strangmann was asked to resign as secretary and treasurer. At that point, Carl and his sister Louise each had one hundred shares of brewery stock. Carl had received his in 1883 with the incorporation, and Louise had inherited hers from her husband's estate. They sold their stock back to their uncle, each receiving $17,500.

Soon after, Carl Strangmann traveled to Cleveland, where he met brewer George V. Muth, a major contributor to the Altenheim. Muth had recently developed several health problems and could no longer operate his brewery. The George Muth Brewing Company was sold on April 24, 1896, for $100,000 to Carl Strangmann and John M. Leicht, the man who'd replaced Paul Mühlhaüser as vice president at the Portner Brewery in October 1890. Leicht would be the new president and Strangmann the new secretary and treasurer.

During that first year, Carl Strangmann resided at a house on the brewery grounds just across the street from previous owner George Muth's residence. The two became close friends. It was Muth who introduced Carl to August Tiedemann, the secretary and treasurer of the Phoenix Brewing Company.

When August Tiedemann learned that Strangmann was living at the brewery, he mentioned that his father was in the process of moving to Lakewood and his Cleveland home would soon be unoccupied.

So it was that in the late spring of 1897, Hannes Tiedemann rented his Franklin Avenue home to Carl Strangmann. Strangmann contacted his sister, and within a month, Louise Mühlhaüser and her six children left Alexandria and joined him in this wonderful new home. Louise Mühlhaüser must have fallen in love with the house at once. On December 6, 1897, she purchased the Franklin Castle from Hannes Tiedemann for $20,000, most of which she'd received from selling her Portner Brewery stock.

Carl Augustus Strangmann, circa 1900. *From* Memorial and Family History of Erie County, New York, *1908.*

It should be noted here that it was Louise Mühlhaüser who purchased the Franklin Castle and not Carl Strangmann, as has been previously related in the legend.

It was also during her ownership that the house underwent two address changes due to city redistricting. In 1902, 283 Franklin Avenue became 504 Franklin Avenue. In 1906, it received its current address of 4308, and Franklin Avenue was finally changed to Franklin Boulevard.

Carl Strangmann remained at the Franklin address until 1899, when he moved to Buffalo, New York, and purchased the German-American Brewing Company.

By 1900, the Mühlhaüser family had settled into their new home quite well. The youngest child, Albert, had become fast friends with next-door neighbor Edward Ralph Wiebenson, both being the same age. Also living with the Mühlhaüsers were twenty-one-year-old servant Julia Malley and forty-six-year-old coachman John L. Vogt. Julia occupied the first-floor bedroom in the home, while John lived in the second-floor apartment of the carriage house.

Sadly, death visited Franklin Castle on the evening of Friday, October 9, 1903, when thirteen-year-old Albert Mühlhaüser succumbed to syncope-

sarcoma. Dr. Hoover pronounced the death, and services were handled by Saxon and Son, Undertakers. Albert's remains were then sent back to Alexandria, Virginia, to rest beside his father's.

Shortly after, Albert's sister, Anna Mühlhaüser, married a man who lived just up the street on Franklin. He was Carl John Weideman, grandson of Hannes Tiedemann's former business partner John Christian Weideman. In 1904, Carl and Anna Weideman and Anna's brother, Ernst Mühlhaüser, left Cleveland for Buffalo, where they joined their uncle, Carl Strangmann, at the German-American Brewing Company. Ernst and Carl became vice president and treasurer, respectively, at the brewery.

Louise Mühlhaüser lived at the Franklin Castle until she sold it on May 26, 1915. She then lived on West 80th Street in Cleveland with her son Otto. Two years later, she moved to Lakewood. Then, in 1926, as her health declined, Louise Mühlhaüser moved in with her son Paul at 1421 Waterbury Avenue, Lakewood. It was there that she passed away on September 25, 1927. She was then buried in Alexandria, Virginia, beside her husband, Paul, and son Albert.

The next owner of the Franklin Castle was not, as every account claims, the German Socialist Party. The new owner was, in fact, a doctor named Ulysses Sherman LeRoy Shirkey.

Dr. Shirkey was born to pioneering settlers in Maple Grove, Seneca County, Ohio, in 1863. A graduate of Ohio Northern University, he received his medical training at the old medical college in Columbus, Ohio, that is now part of The Ohio State University.

He wed Mary Brockman in 1889 and began his medical practice in Tiffin, Ohio, the following year. In 1891, he relocated to the west side of Cleveland, where he and his wife would eventually raise two children: Martha and LeRoy.

Dr. Shirkey's home and office were located on Lorain Avenue. He'd make his rounds beyond the city limits by horse and buggy and was instrumental in compiling a book that listed the names of patients who didn't pay their bills. The advent of this book proved helpful to other area physicians. If a person was listed in it, the doctor could ask for payment up front.

When Dr. Shirkey learned of a grand house for sale not far from his office, he purchased it on June 3, 1915. Dr. Shirkey moved with his family into the Franklin Castle but retained his office at 6404 Lorain Avenue.

The doctor's son, LeRoy, who had been a pilot on a Great Lakes freighter for five years, left that occupation at the end of the 1919 shipping season. At this, he opened the Franklin Auto Repair Company, located in the carriage

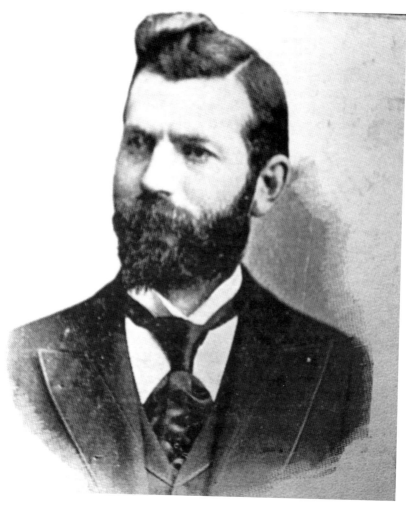

Dr. Ulysses Sherman LeRoy Shirkey. *Courtesy of the Cleveland Public Library Photograph Collection.*

house behind the Franklin Castle. The main floor was large enough to work on multiple vehicles at one time, with easy access to their undersides. Located in the center of the floor was a small trapdoor with access to a pit in which one could stand while servicing the under-workings of automobiles. This was better than crawling underneath in very cramped conditions. The pit also had a short tunnel that was perfect for storing tools.

In 1921, LeRoy moved with his wife, Edna, and newborn child, Ruth, from the Franklin Castle to a home on Lorain Avenue near his father's office

but retained his service garage at his father's home. Before summer's end, he'd need to relocate his garage as well. After just six years, Dr. and Mrs. Shirkey sold their house.

The Shirkeys purchased a grand home at 9912 Lake Avenue in Cleveland, where they would live out their days. The doctor was noted among his new neighbors for keeping beautiful gardens on his property, which still exist today.

Dr. Shirkey's wife of forty-eight years, Mary, passed away on April 16, 1937. After this, LeRoy Shirkey moved with his wife and children to Columbus, Ohio, and returned to his former job of sailing on the Great Lakes. He was working as the third mate of the steamship *William B. Davock*, a 7,200-ton freighter, during the 1940 shipping season.

On the evening of November 11, 1940, the *Davock* was on Lake Michigan with a load of coal bound for South Chicago, when a sudden gale blew up. The gale blew hard and long, and by the next morning, more than twenty ships were wrecked, aground or missing. Among these was the *William B. Davock*, which was smashed to pieces in what became known as the Armistice Day Storm. LeRoy Shirkey managed to escape the wreck in a lifeboat with seven other men, but all died from exposure. There were thirty-three souls aboard the *Davock* when it foundered. All hands were lost.

Dr. Shirkey followed his son on January 8, 1945, passing away at his home on Lake Avenue. Two weeks earlier, he'd caught a cold and, shortly thereafter, stopped visiting his patients. He'd been in excellent health throughout his life and had only been ill once, around 1916, when he'd contracted influenza. He always attributed his good health and unfailing activity to his temperate habits. Dr. Shirkey was eighty-two.

It's unfortunate that such a prominent person should be overlooked when tales of the Franklin Castle are told. Dr. Shirkey has never been mentioned in relation to this story until now.

Many years later, LeRoy Shirkey's widow, Edna, would recount her experiences in the Franklin Castle to her family. According to her great-granddaughters, Edna would claim that things would constantly move around on their own. Also, their blankets would be pulled off of their beds in the middle of the night. These are the earliest reports of paranormal activity at the Franklin Castle. Events matching those reported by Edna would be experienced by others who would occupy the house some fifty years later.

SOCIALISTS, BOOTLEGGERS AND SPIES

During the late nineteenth and early twentieth centuries, the growing number of immigrants found comfort in socializing with those who shared their common background, language and customs. Ethnic cultural and social clubs were the natural result.

Just as Hannes Tiedemann was moving from his Franklin house in 1897, a German men's singing society, called the Bildungsverein Eintracht Liedertafel, was formed in Cleveland. Over the next twenty years, various German nationalist groups and singing societies, such as the Liedertafel der Sozialistischen Partei, or Socialist Party Singing Society, were formed and eventually merged with one another. This resulted in the Franklin Improvement Company and Bildungsverein Eintracht Club.

On July 22, 1921, the Taylor Waag Company purchased the Franklin Castle from the Shirkey family. A week later, the house was placed in the name of the Franklin Improvement Company and now became home to the Bildungsverein Eintracht Club.

It should be noted that this was just after the Great War, in which Germany was an enemy combatant. The Franklin Castle would now serve as a private clubhouse for German Americans for the next forty-six years. This would be the longest that any person or group would maintain ownership. It would include Prohibition and the Roaring Twenties, the Great Depression, the Second World War and the threat of Communism. What were the German Americans doing inside the castle?

Immediately, major alterations were made to convert the home into a clubhouse. They created one large room on the second floor by removing

the walls that divided the parlor, dining room and front hallway. For privacy, the windows were covered with white paint. The wall separating the servants' parlor from their dining room on the first floor was also removed. Meanwhile, the dry storage room was sealed off and made accessible only by removing a piece of wainscot paneling that covered where the door to the servants' parlor had been.

A caged door, lock and buzzer were installed on the landing between the second and third level to limit access beyond that point. On the third floor, the wall separating Hannes Tiedemann's former bedroom from his sitting room was removed. A lengthy bar was constructed in the dressing room off of the sitting room. Finally, the house was completely wired up with electrical lights by running knob and tube wiring through the old gas lines. The gas well was also filled in. According to rumor, old furniture left in the house was used to fill the empty space.

From 1920 to 1933, prohibition of the manufacture, sale and transportation of alcoholic beverages was the law of the land. Renovations to the clubhouse included a security door to the third floor, which contained a bar, and the secreting of the first-floor dry storage room, which contained a liquor still. The Franklin Castle was anything but dry.

The rumors of the tunnel in the carriage house being used to smuggle liquor onto the property from Whiskey Island seem doubtful. The tunnel was not that long and had no outlet on the north end. Besides, the carriage house was being used by Arnold and Walter Dobay from 1922 through 1925 for the Mayer Carburetor Distributing Company. Afterward, the carriage house was converted into the Eintracht Club's gymnasium.

The house was referred to as Eintracht Hall or the Clubhouse by its members. Many groups met there on a regular basis during the 1920s, including the Sozialistische Liedertafel, a section of Branch 5 of the local German Socialist Party. The Workmen's Sick and Death Benefit Fund No. 188 Lake Erie Chapter, a group that published the periodical *Solidarität*, met every second Tuesday. Two singing groups under the direction of Rudolph Schuster, the Freiheit Frauen Gesangverein and the Liedertafel Eintracht, used the hall. The Geselligkeits Klub held meetings there in 1927, and by the 1950s, the German-American Chess Club also met there.

In 1930, the Bildungsverein Eintracht Club bought a tract of land at 11533 Royalton Road in North Royalton, Ohio. Known as Eintracht Farm, it was used for sporting, cultural and social events. Four structures occupied the property: a two-story dance hall and rathskeller, a bowling alley, a fresh-air dormitory and a refreshment booth. The Workmen's Sick and Death

Benefit Society built the fresh-air dormitory on a section of the farm it leased from the club.

The Eintracht Club was, first and foremost, a singing group, and there were many festivals held by the club, celebrating German heritage.

Various members, who served as facility managers and caretakers, would live at Eintracht Hall on Franklin for one year at a time. Carl and Anna Fuerhof were caretakers at Franklin Castle in 1937. Their daughter, Elsie A. Ruhrkraut, who was only eleven or twelve at the time, remembered that the home was very big. She recalled playing with a friend in the carriage house and seeing a lot of gymnasium equipment in there but no tunnel. She said the club held meetings during the week. Everyone entered through the side door, and hardly anyone entered through the front. While the men's chorus practiced on the fourth floor, the women played cards in a room on the third floor.

Mrs. Ruhrkraut recalled the layout of the house. The kitchen was on the first floor in the former servants' bedroom, with the rest of that floor being used for storage. The room on the second level, formerly the parlor, dining room and hallway, was used as a dance floor. She and her parents occupied the back bedrooms on that level. On the third floor was the bar. Pool tables were located where Hannes Tiedemann's bedroom and sitting room had been. The back rooms contained card-playing tables. The fourth floor was the ballroom where the singing groups practiced and performed.

When asked about the rumors of rumrunning and illegal moonshine production during the Prohibition era, Mrs. Ruhrkraut laughed but then said that she wouldn't doubt it. Over the years, she received many newspaper articles about the Franklin Castle from her friends because they knew she had briefly lived there. She remembered reading a story that claimed a murder had taken place in the second-floor hall, but she didn't know anything more than that. As for ghosts or paranormal activity, she recalled nothing of the sort. She once tried to speak with a reporter about this, but he didn't seem very interested. She remembered the house creaking a lot but attributed that to an aging structure and settling floorboards.

Gary Krueger, who was ten years old when his grandparents were Eintracht Hall managers, also remembered his experiences there. On the one hand, he said that the house could look awfully scary, though he never saw a ghost or anything like that. On the other hand, he remembered it was a fun place to play. There were pool tables, which were a lot of fun. Often there was an abundance of playmates, as parents would bring their children

Main hall on the second floor of the Franklin Castle, which had formerly served as a hallway, dining room and parlor, with the carriage house of the Franklin Castle being used as a gymnasium, circa 1942. *Courtesy of the Cleveland Public Library Photograph Collection.*

to the clubhouse. One of the features of the house that he remembered best was the wide stairway, with its ornate woodwork.

Krueger never heard any stories of rumrunning or secret tunnels, but Prohibition was before his time. The stories of Nazi spying and a mass execution were ridiculous fabrications. Who would know better than Krueger? It was his grandparents and their friends who occupied the house throughout World War II. The Eintracht Club was a very family-oriented society, and its members were like family.

Jacob Enz became the caretaker of Eintracht Hall in late 1942. The forty-eight-year-old Enz was unmarried and had worked as a gardener much of his life. His tenure at the club was brief. On May 6, 1943, he became the third person known to have died inside Franklin Castle, preceded only by Louise Tiedemann and Albert Mühlhaüser.

Following World War II, relations between the United States and the Union of Soviet Socialist Republics were plagued with the specter of suspicion and distrust. It was the beginning of the Cold War. In March 1949, a man named Eugene Dennis and ten other Americans were put on trial in New York City, accused of being communists and attempting to overthrow the U.S. government.

On May 9 of that year, one William Cummings took the stand to testify against the accused conspirators. In 1943, FBI officials placed Cummings as an informant within the rank and file of the Communist Party. He became vice chairman of the organization in Lucas County, Ohio, where in 1945, he heard whispers of rebellion.

According to Cummings, party officials said at a meeting that year that they expected world conditions to bring about a violent revolution in the United States that would result in a dictatorship by the working class. Two Communist Party officials, whom Cummings identified as Adeline Kohl and Paul Presser, said they first estimated this revolution would come to America around 1955. Recent changes in the world, however, led them to conclude that it was much closer than they'd first thought.

William Cummings went on to say that the American Communists had set up secret party schools in 1945. He told the court that the orders for these schools came from the party office in Cleveland in June of that year. The Ohio schools were to be held for one week each on the Eintracht Farm, or Camp Solidarity as he called it, in North Royalton. John LaBlanc, another FBI informant, backed up this testimony. Cummings produced a letter that stated that Pop Mindel, an outstanding communist speaker, would lecture classes in their orientation into Marxism.

This announcement came as a shock to officials at Bildungverein Eintracht. Max Luehr, Eintracht Club president, rebutted by saying that the building in which this was supposed to take place was built by the Workmen's Sick and Death Benefit group and that the section of the property on which the building stood was leased to them. It was also his understanding that the building was being used as a children's fresh-air camp. He expressed amazement to learn there was anything going on against the U.S. government and that they never would have permitted it had they known anything about it.

Carl Marx, the Franklin clubhouse manager and Eintracht Farm custodian, recalled that a group had used the fresh-air camp in 1945. Some sort of classes and meetings were held, but he didn't know what they were doing.

On August 2, 1949, Edward Joseph Chaka was called to the stand to refute Cummings's and LaBlac's allegations. Chaka, a Cleveland foundry worker, stated that the testimony about a Communist Party school being held at Eintracht Farm was completely false and that their accounts of the goings-on at the school were inaccurate.

After a nine-month trial, the eleven American Communist Party leaders were found guilty. They were sentenced to five years in prison and fined $10,000 each. There was an immediate appeal to the U.S. Supreme Court, but on June 4, 1951, the justices upheld the ruling.

While this episode may have changed the image of the Franklin Castle for some people, what happened next would dramatically change its image forever.

The afternoon of June 8, 1953, had been hot and muggy. The forecast of rain seemed to promise some welcome relief, but the thunderstorms advancing across southeastern Michigan and western Ohio had a history of tornadic activity, producing at least one cyclone in Flint, Michigan.

By sundown, tall clouds were building to the west, and Cleveland skies turned to an ominous greenish color. At 9:45 p.m., radar at Cleveland Hopkins Airport detected a tornado forming over the West Park area, 3.7 miles from downtown Cleveland. The funnel touched down and raced in a northeasterly path of destruction. It crossed through the West 117th Street and Lorain Avenue neighborhood and was soon in Ohio City with winds between 207 and 260 miles per hour. It proceeded across the Cuyahoga River, whipped through downtown and, at 10:12 p.m., moved out over Lake Erie around East 40th Street.

The tornado lasted just twenty-seven minutes and left Cleveland's west side in utter ruin. Nearly two thousand homes were damaged. The human

damage was worse, with 379 injured and 17 dead, including a three-and-a-half-month-old baby who was torn from his mother's arms. Five died when their home on West 28th Street near Franklin collapsed on them.

Ohio City was the worst-hit neighborhood by far. Until then, there had been a line of very old English pin oak trees that formed a beautiful archway over Franklin. After the category 4 tornado, nearly every single tree had been destroyed.

Three area landmarks also suffered major storm damage. St. John's Episcopal Church lost many of its beautiful features. The YMCA on Franklin was damaged too. The Franklin Castle was also a victim of the storm's attack. The point of the turret, including the tall finial that graced its top, was ripped cleanly away, as were the beautiful sandstone dormer located directly above the front entrance and the porte-cochère over the side entrance. The house was soon repaired, though nowhere near to its original splendor. The turret cone was cut short of reaching a point, and the missing dormer was replaced by a shingled triangular-shaped wall. Many years passed before these repairs would be corrected.

During the mid-1950s, rumors of a haunted Franklin Castle began to emerge throughout the neighborhood. One area resident, Nunzio DiMassa, recalled an incident. Then a teenager, DiMassa and a friend were escorting two young ladies past the castle and tried to get them to approach it. Both girls boldly stated that the house was haunted and that neither of them wanted anything to do with it.

Eleonora Kray fondly recalled her memories of the Eintracht Clubhouse in a newspaper article that appeared in the mid-1970s. As a young girl, her parents brought her with them to the house, where she spent many hours playing while the choir practiced. She later joined the drama and gymnastics clubs there. She also remembered singing and playing the piano there and the many wonderful parties held by the club.

Never at any time did she encounter the slightest hint of paranormal activity. "I had a beautiful youth down there as a child," she stated. "We never heard no spooks, no rattling."

As club managers, George Warren Fichter and his wife, Ruth, took up residency at 4308 Franklin Boulevard in 1955. George was also employed by a company called Ceramic Research, from which he retired in 1964. Mr. and Mrs. Fichter were to be the last to serve as caretakers of Eintracht Hall. George Fichter died at the Franklin Castle on January 7, 1966.

Almost two years later, on January 3, 1968, the Franklin Improvement Company transferred the title of the Franklin Castle property to the

Bildungsverein Eintracht. The property was then immediately sold to the next owners.

The next year, Eintracht Farm in North Royalton was closed and sold off. The remnants of the Bildungsverein Eintracht were reorganized into the Bildungsverein Eintracht Singers in 1988, and the group disbanded in 1993.

The last president of the Eintracht was Elizabeth Horn. According to her, Mannerchor Hall on State Road in Cleveland was the last site for club activities and meetings. She fondly remembered the many parties that they hosted at Eintracht Hall on Franklin, as well as the singing in the ballroom and the dances on the second floor. She remembered cooking in the first-floor kitchen for the many dinners shared and celebrated at the clubhouse.

As far as any ghostly activity goes, neither she nor anyone she knew ever witnessed anything strange at the Franklin Castle. To them, it was just a beautiful house.

WONDERLAND

Dolores Shaw was born on March 1, 1925, in Brownsville, Pennsylvania. At a young age, she came to Cleveland, where she met and married William E. Ocheltree. Born to them were two sons: Kenneth and William Jr. One day, while going down Franklin Boulevard, she came across the large and brooding home with its windows painted over. Her first impression was that she couldn't believe how dirty the windows of *her* house were.

James C. Romano was born in Cleveland, Ohio, on November 17, 1926, and grew up on the west side. He was married as a young man and had two children as well: Vincent and Christine. When James was still a boy, he would occasionally walk down Franklin Boulevard. Whenever he approached the turreted sandstone house that sat at no. 4308, he would run past as quickly as he could in fear. Little did he know, one day he would own that house, and his fears may have been well founded.

After a number of years, William and Dolores were divorced. Soon afterward, Dolores became acquainted with James Romano, who was also now single. The two became very close and on June 20, 1964, were wed. Almost immediately, they began to extend their already extended family. Over the next five years, Dolores gave birth to two sets of twins, Jimmy and Dee Dee, followed shortly after by John and Jeff. A fifth child, Debbie, was born shortly after the Romanos moved into the Franklin Castle.

Nearing the end of the 1960s, James and Dolores purchased a storefront located on Lorain Avenue near West 44th Street, where they briefly operated Romano's Restaurant. The City of Cleveland would use eminent domain

to purchase this property from them and tear down the building to make way for a methadone clinic. Still desiring to run a restaurant, the Romanos searched the neighborhood for a new location.

They once again found themselves standing outside the house at 4308 Franklin Boulevard. Mrs. Romano had passed the home several times recently and one day noticed it was for sale. After she mentioned the house to her husband, they agreed it would make a wonderful location for a restaurant. On January 3, 1968, the Bildungsverein Eintracht Club sold the house to James and Dolores Romano.

Previous stories about the Romano family state that on the day they moved in, two of the children came down from the third floor to ask their mother if they could have a cookie for their friend, the little girl sitting on the stairs crying. When Mrs. Romano investigated, she found the third floor empty.

There is, in fact, some truth to this story.

Jimmy Romano, a son of Dolores and James, clearly remembered the incident. He also remembered that this didn't occur on the third floor, but rather on the fourth, very close to where the dumbwaiter service let off. Furthermore, it happened on more than one occasion. His twin sister, Dee Dee, also remembered these incidents quite well. The little girl, as she recalled, appeared to be about their age. One time, Dee Dee even managed to talk to the girl. When she offered to go and call the little girl's mother for her, the girl simply told Dee Dee that she couldn't. When asked why, all that the little girl would say was that her mother wouldn't come to get her.

Jimmy recalled that the girl was a lot like having an imaginary friend, only she wasn't imagined. As the Romano children grew older, they realized that seeing the little girl wasn't a normal thing. Gradually they became more and more afraid when they'd see her. Eventually, the girl stopped appearing to them altogether.

When the Romanos moved into the house, it was in something of a state of disrepair. For starters, there was only one room in the house that had working electricity, that being the first-floor servants' bedroom. Wires ran to other parts of the house but weren't connected. Mr. Romano, an electrician with the Ford Motor Company, took it upon himself to rewire the entire house. A problem that would be reported in the years that followed would be that many light bulbs would burn out after only a few weeks' time. Jimmy Romano remembered that the dumbwaiter was wired up for electricity but only connected to the main circuits when his father rewired the house. Mr. Romano also replaced its motor. The dumbwaiter obviously wasn't intended to carry passengers, though Jimmy remembered that he'd ridden in it once or twice.

The Romano children in front of the Franklin Castle. *Courtesy of the Romano and Ocheltree families.*

The walls were in pretty bad shape as well, being something of a sooty-brown color. Immediately, the family decided to hang wallpaper. The lowest floor was finished in silver and white damask patterns, and the upper floors were done with similar prints, with the back bedrooms in silver and the large room in the front in red. Mrs. Romano wanted the house to emulate the era in which it'd been built and did her best to make it so. Fixing up the house also meant removing the white paint from the windows. While doing this, the name of one of the Mühlhaüser children was discovered etched into the glass. In the fourth-floor ballroom, the crest for the Bildungsverein Eintracht had been painted on the wall. This, the Romanos painted over. The cage door was also removed from the landing between the second and third floors.

Another problem was that the floorboards on the first level were almost completely rotted away. A replacement floor was needed. Fortunately, Interstate 90 was being built at that time, and many houses were being torn down to make way for the new freeway. One person who'd salvaged much of the scrap from these houses was a man named Gus, who owned Gus'

Wrecking Company in the Flats. Mr. Romano was a friend of Gus, and on occasion, his son Jimmy would pull nails for him. A new floor for the first level was purchased from Gus, as were two wooden fireplaces for that level.

Tearing out the old floor was quite a project. That job fell to Bill and Ken Ocheltree, Mrs. Romano's sons from her first marriage, who were then living in the house. As the two removed the old boards, they found a sandy dirt base underneath. Just as they were completing the job, Bill removed a floorboard that was up against the wall beside the servants' stairwell in the front of the house. The next thing he knew, one of the vertical baton board wainscot panels came crashing down on his head, leaving a bump of considerable size. After Ken checked to see if Bill was okay, the two brothers realized there was an open space behind that panel. Peering inside, they discovered another room, which had once been the Tiedemanns' dry storage room. Carefully tucked away in the back was the forgotten Prohibition-era liquor still that had been left behind by the Eintracht. Along with this were quite a few antique liquor bottles. The house was full of hidden treasures.

There were many pieces of furniture left in the house by the Eintracht Club. Some of these pieces were rumored to have been left by the Tiedemanns. Most of this was auctioned off shortly after the Romanos moved in. One item in particular was an old rocking chair, believed to have belonged to Louise Tiedemann herself. The person who purchased this shortly returned it, claiming it would rock on its own accord. They claimed it was haunted.

One of the most important discoveries in the house was a library, comprising more than six hundred volumes of German and American literature, as well as several books of Socialist propaganda, dating from 1845 to 1925. These were also found in the hidden room on the first floor. Included in this collection were several bound volumes of the *Echo*, a periodical published by the renowned German socialist Dr. W.L. Rosenberg, as well as quite a few volumes of the *Solidarität* and the English language periodical the *Pioneer*. Also found was a large oil portrait of Karl Marx.

Quite interestingly, many personal documents about Socialist meetings and memberships were discovered. These, along with the bulk of the Socialist library, were sold in 1971 to a German foreign diplomat working in Cleveland named Peter Schoenwaldt. He'd learned of the library a year earlier from a friend who worked as a book dealer in Cleveland who had asked him if he'd be interested in purchasing "some German junk." At first he'd passed on the offer but later had an idea to write an article about the discovery of these books. Writing this article never came to fruition, as the life of a diplomat rarely allowed for such leisure activities. It was Mr. Schoenwaldt who, while

Dolores and James Romano with a portrait of Karl Marx found in the Franklin Castle in 1968. *Photo by Glenn Zahn; Cleveland State University Library.*

reading over minutes from a socialist meeting, discovered an entry making reference to a radio tower atop the turret, thus beginning the stories of Nazi spying. The minutes from the meetings, along with the rest of the club documents, were presented by Mr. Schoenwaldt to the Case Western Reserve University in hopes they could be of use to the descendants of early members of the club. The propaganda library remained in Mr. Schoenwaldt's possession for at least the next thirty years, though word has it that it was later taken over by a secondhand bookshop in Vienna.

Soon after moving into the home, the Romanos' plans for opening a restaurant in the house were put to rest. The original plan was that the house could be used for banquets and small parties. This plan was abandoned when a local councilwoman stepped in. She wouldn't allow anything of the sort on the premises without a rezoning change. That could only happen if the Romanos tore down the carriage house in the back to allow room for more parking, something they refused to do.

Another story told from this period is about how Mrs. Romano's two sons from her previous marriage were chased from the home after their blankets were torn from their beds one night. Jimmy Romano not only remembered this but also recalled that it happened on more than one occasion. The room that the two were occupying was formerly Louise Tiedemann's bedroom on the third floor, the one beneath it being occupied by Mr. and Mrs. Romano and the other on the second floor being occupied by the rest of the children who slept on bunk beds. When asked about the blanket incident, Ken Ocheltree preferred not to discuss the matter. Whatever the case may have been, both Ken and Bill Ocheltree resided at the house for a very brief time before moving to Lakewood.

Word was spreading about the house's haunted reputation, and by mid-September 1968, a newspaper article, the first to report on the strange occurrences, appeared in the *Cleveland Press*. The article's author, Mary

Swindell, reported that neither Mr. nor Mrs. Romano believed in ghosts. On the other hand, there were some strange incidents, a few of which couldn't be explained.

Mrs. Romano claimed that while doing some cleaning on the third floor, she heard what sounded like a chain being dragged across the floor above. The house always seemed to be full of unusual sounds. Most of these, however, were attributed to wind. Bearing that in mind, Mrs. Romano recalled an evening she had heard what sounded like organ music. She found no source for this and simply allowed it to lull her to sleep. Ken Ocheltree recalled one night when he traced the music to the first level. He noticed that the sound was actually coming from the floor itself. Soon after, he walked outside and realized that it was originating from one of the neighboring homes and the noise was likely traveling through the sandy ground beneath the houses.

According to Mary Swindell's article, the Romanos were pulling buckshot out of much of the woodwork on the third floor near the bar, though none of Mr. and Mrs. Romano's children recalled this. The article also stated that shortly after the Romanos moved in, neighbors beat a path to the door to tell stories of a thirteen-year-old insane girl that was hanged by her father in a room on the fourth floor.

In researching the facts for this story, Mrs. Swindell managed to locate a grandson of Hannes Tiedemann's, Edward Ralph Wiebenson, Dora and Edward's eldest son. This would be the only time that Dora or her family would ever be mentioned in any history of the house. Any article that followed simply said that Hannes Tiedemann outlived every member of his family, and furthermore, none of these would ever mention him having a daughter named Dora. To make matters worse, Mrs. Swindell's article named Edward Wiebenson as Edward "Weideman." This confusion stems from when Mrs. Swindell researched Hannes Tiedemann's back story and came across John Christian Weideman as a business associate.

Edward Wiebenson recalled that he used to go to the house when he was a kid and that it was quite big but didn't really know why his grandfather had built it. After hearing tales of the thirteen-year-old hanged girl, Mr. Wiebenson laughed the story off but added that it might have happened. At this, he stated that his family moved away in 1910, following the death of his father, and he didn't know what happened to the house after that. Shortly after the article was printed, Mary Swindell realized her error in misnaming Hannes Tiedemann's grandson and sent an apology letter to him.

After the idea for the new restaurant was put down, another idea soon came to mind. With the stories of the haunting beginning to spread, Mr. and

Mrs. Romano realized they could open the house for tours. It was then that the name Franklin Castle was first introduced. The idea of calling it this was Mr. Romano's, as he thought the house very much resembled an old castle. The name has stuck with the house ever since.

Vincent Romano, Mr. Romano's son from his first marriage, recalled that these tours were given around midday on Sundays and usually consisted of groups of five to ten people. Although he didn't live there, the house being too unusual for him to reside in, Vincent assisted with the tours. Vincent's brother, Jimmy, remembered that these tours were mostly given around Halloween. At first, the Romanos charged a dollar for the tours, but each year, the price went up. Eventually, they were charging five dollars per person.

To add to the mysterious appearance of the house, Mr. Romano purchased many statues from a friend named Al, who was an auctioneer. These were placed throughout the home. Two of these statues, a matching pair of stone lions, were placed outside of the home flanking both sides of the front entrance. One time, a couple of men attempted to steal them but were unsuccessful. When the Romanos moved some years later, they took these lions with them.

Unfortunately, it was during a tour that one of the treasures found in the house went missing. Shortly after moving into the home, Mrs. Romano discovered a letter that had been sent to one of the members of the Eintracht Club. The letter had been dictated by Helen Keller and was kept in Mrs. Romano's jewelry box. Its disappearance was quite upsetting.

Just after the family moved in, one of the house's long-kept secrets was hidden. Jimmy Romano recalled the tunnel located in the carriage house in the center of the main floor with a hatch about the size of a large manhole covering the entrance. Beneath this were steps that led down, and from there, the short tunnel ran north. The hiding of this took place when Ken and Bill Ocheltree covered the tunnel entrance with cement. This was done to keep the younger children from playing in it. Though when asked about this, Ken Ocheltree didn't have any recollection of it.

During these early years, a couple of strange incidents occurred involving the stairway, the first of which was when Mr. and Mrs. Romano's youngest child, Debbie, fell down the stairs while in her baby walker. Miraculously, she escaped the incident completely unscathed. The same could not be said for their babysitter, who lived with them for a time. Karen Dillon Brown was a family friend, and on one occasion, she and Ken Ocheltree were arranging some books on an upper floor when an incident occurred. While moving

these books, Karen was pushed by some unseen force down the stairs. She was fairly banged up from the fall and shortly afterward moved out, though her moving had nothing to do with this incident. Karen had recently graduated and wished to start her life. Still, word quickly spread about what had happened, and soon, stories were circulating about a "servant girl" named Karen who had been killed in the house many years earlier. It's amazing how some legends have their origins.

As time wore on, a few further renovations were made to the house. The beautiful glassed-in office on the second level was converted into Mrs. Romano's sewing room, and the former servants' bedroom on the lowest floor was converted into a kitchen. It was also at that time that Mr. Romano decided to remove the long bar the Eintracht Club installed on the third floor. This was done mainly because it wasn't original to the house and did not match the rest of the interior. The plan was to replace it with a smaller bar, which he did after removing the wall that separated Dora Tiedemann's former bedroom from what had once been the ladies' guest bedroom.

To start with, the third floor always seemed a bit on the cold side. When Mr. Romano removed the long bar, he discovered why. Where the bar made an L-turn and met the wall, he found a window behind it that had been sealed up, and worse yet, the window had been left open about six inches to a foot. Also found next to the open window was a note left by one of the bar's original builders that said "Hot as Hell, Ha Ha!"

As the years passed, the unusual disturbances began to occur with greater frequency. Mr. and Mrs. Romano's daughter Dee Dee remembered that the bedroom door would open and close of its own accord. Furthermore, there was an incident when she was sitting in the bedroom reading a book. When she'd finish reading a page, she'd say, "turn the page," and the page would turn. She did this a few times and thought it amusing. After telling her mother about this, she was told never to do it again.

Dee Dee's twin brother, Jimmy, remembered that certain items would go missing around the house and turn up some time later in a completely different place, sometimes even on a different floor. One of the most common disturbances was the sound of footsteps moving across the upper floors when nobody was up there.

For a time, the future of the Franklin Castle looked uncertain. A group that was interested in purchasing the house and moving it to New York City approached the Romanos about doing this. The plan was that blueprints for the house would be drawn up, each block would be numbered as it was removed and the house would be reassembled just as it had stood in Cleveland.

A surveyor came in, measured the position of the house in relation to the property pins and learned that it hadn't shifted more than one quarter of an inch in the ninety years it had stood. Eventually, Mrs. Romano decided that she didn't want to sell the house to this group and firmly believed it should remain in Cleveland. Though the move never happened, she ended up with a copy of the blueprints.

As the disturbances continued, the children were eventually forbidden to play on the third and fourth floors, which were primarily used for storage. The first floor served as the children's play room, though playing outside seemed a far better alternative. Jimmy Romano recalled playing in the backyard, where he'd often dig holes in the sandy ground. Some of these holes were so deep that he'd be able to hide in them completely. One time, he found a very old ice skate buried in the dirt, which makes one wonder what else might be buried on the property. Jimmy also recalled that he got in trouble on more than one occasion for digging these holes.

Playing outside was fine for a while, though soon curiosity seekers started coming up to the house to take pictures. Some people even started photographing the Romano children. One year it got so bad that Mr. Romano had the children's bikes and swing set moved into the main room on the second floor. Eventually, people got so bold as to even come onto the property to take pictures. Little did they know the Romanos owned a dog named Tootsie, which Jimmy had named after the Tootsie Roll. Tootsie was notorious for biting people who would come into the yard to get a closer look. This was accomplished by hiding around a corner and waiting for the unsuspecting trespassers. One time, Tootsie even ripped the seat off of someone's pants.

Soon, the house was being visited by some of the most unusual guests. People claiming to be white witches, black witches, psychics and mediums all wanted to see it. One time, a man in a cape showed up at the front door wanting to come in. These total strangers couldn't understand why they wouldn't be admitted. On one occasion, a woman sent over a box of items hoping that Mrs. Romano would be able to help find her missing child.

It seemed that the only people who wouldn't want to come into the house were Mr. Romano's parents. When they would come over for a visit, they remained in their car in the driveway. If Mr. Romano ever tried to invite them in, his mother would refuse, telling him that she wouldn't go into the house because it was evil.

Mrs. Romano would occasionally have over a newspaper reporter or legitimate paranormal investigator. It was on occasions like these that

she would send her children next door to their babysitter's. One of these legitimate investigations was conducted by a group of seven students from John Caroll University. This was to be done on a long-term basis, as the students would live with the Romanos for an extended period of time. These students resided on the third floor and in the bedroom on the fourth. Until now, that bedroom had been used as Mr. Romano's clock room. After being there a few days, they came back to find their rooms ransacked and immediately suspected that the Romano children had gone through their possessions, which, of course, they hadn't.

While searching the fourth floor, these students stumbled across one of the passages that paralleled the ballroom, where they made an incredible discovery—yet another of the house's many treasures. Within this passage, they found an old photograph as well as an oil painting of a young girl holding a basket of eggs. Upon showing this painting to the Romanos, the children grew ecstatic. There was no mistake about it. The girl in the portrait was the same girl they'd seen on the fourth floor near the dumbwaiter service when they'd first moved in. As for the photograph, it was of Hannes, Louise and August Tiedemann, most likely August Tiedemann's graduation portrait.

The painting of the girl, which had eyes that seemed to follow you across the room, remained with the Romano family until early December 2006, when it was donated to the Goodwill in Elyria, certainly a wonderful find for some lucky soul.

Unfortunately, the college students made a habit of staying up late and making too much noise, which Mr. and Mrs. Romano couldn't tolerate, as they had young children in the house. Also, they had brought in a Tarot deck and Ouija board that Mrs. Romano had asked them not to. The students were asked to leave after only a month.

For a brief time following the students' stay at the castle, a man named Lance Toko occupied one of the upper floors. On one occasion, a statue that he'd owned, a bust of Mae West, was found destroyed in his bedroom, the head being completely separated from the shoulders. Toko immediately blamed the Romano children, though to this day they deny that any of them had broken it.

Aside from the problem of new light bulbs constantly burning out, the house also proved rather expensive to keep heated during the winter months, as it was heated by a steam radiator system with a large boiler in the first-floor coal room. Heating bills reached as high as $300 a month, almost completely unheard of at that time.

Many different stories have been told in regards to the Romanos' departure from the Franklin Castle. One of the most common of these tells that the spirits that inhabited the house finally drove Mrs. Romano to the brink of madness. This is, of course, completely preposterous. In fact, it should be pointed out that many of the newspaper articles written at that time took much of what she'd said out of context. Jimmy Romano firmly explained that many of those articles made his mother out to be something of a flake, which she definitely wasn't.

Another story claims that Mrs. Romano received a warning from a medium telling her that if she didn't move out of the house, one of her children would die. Never was there such a prediction made. This story stems from someone doing research on the Romano family and learning that one of their children had tragically died shortly after the family left the house.

On the evening of Saturday, September 4, 1976, Mr. and Mrs. Romano's eleven-year-old son John had been playing near the road in front of the new family home on U.S. Route 42 in West Salem, Ohio, with some friends. At one point, he ran out onto the road and into the path of a northbound vehicle. According to the Medina County Sheriff's Office, the driver braked and swerved but couldn't avoid hitting the child. John Romano was taken to Lodi Community Hospital, where he died from his injuries. The fact that anyone would twist this tragedy to make the story of the Franklin Castle sound more interesting is quite disturbing.

The truth behind the Romano family's moving is actually very simple. In the early part of the 1970s, the City of Cleveland began to make changes in its school system. These changes included bussing children from their own neighborhoods to different parts of town. Mr. and Mrs. Romano didn't like the idea of the city deciding which schools their children would attend. It was at this that they decided to put their home up for sale.

In the late summer of 1974, a new owner was found, and the Romanos relocated to West Salem. The children felt somewhat out of place in their new community, having lived in the city their entire lives. Mr. Romano, in particular, didn't really care for living that far out. One would think this would be the end of the Romanos' part in the story of the Franklin Castle, when, in fact, they would still have much more involvement with the house in the years to come.

13

A Proposed Church and a Misleading Article

On September 10, 1974, Dolores and James Romano entered into a land contract with Samuel J. Muscatello, the next owner, for the sum of $34,254.45. Muscatello was to pay the Romanos $12,000 upon taking possession of the Franklin Castle and then pay $293 per month, plus interest, until the full amount was paid off. Although not listed as owners, Sam had two partners: Reverend Timothy Swope and Philip Shelton.

With this done, the Romano family moved to West Salem, Ohio.

Once in possession of the house, the three men conducted tours, charging adults $1.50 and children $1.00. Sam Muscatello didn't believe the place was haunted, but that was about to change.

On one occasion, as Sam was leaving the third floor, he was startled when a shadowy light dashed past him and up the stairs to the fourth floor. When he returned to the third floor, he gazed up the stairs to the fourth floor and saw the light coming back down. Sam claimed the object passed right through him, freezing him in his tracks for about five seconds. Though it was an eerie feeling, he claimed the encounter didn't really scare him.

Later, on January 17, 1975, while cutting through a wall where the third-floor guest bedroom had been, Muscatello discovered an empty space. Well, actually, it was not so empty if you consider the brittle human bones found there.

These remains, two femurs and a partial pelvis, were turned over to the Cuyahoga County Coroner's Office, where they were examined by deputy

coroner Dr. Lester Adelson. It was immediately obvious that these were very old bones. The lack of a complete skeleton made it impossible to determine the age, race or sex. The most that could be said was that the individual had been about sixty-five to sixty-seven inches tall if male and a little shorter if female. The bones of the unknown person were cremated and disposed of.

There would be later speculation that Muscatello or one of his friends planted the bones to enhance their tours, but this has never been proven. In fairness, there are other—but unlikely—explanations. It's possible that former resident Dr. Shirkey had an articulated skeleton for study or demonstration purposes. Still, the question begs to be asked. What happened to the rest of the skeleton?

Not surprisingly, the discovery brought renewed media interest in the Franklin Castle. Thus far, research about the house and its history had been haphazard at best. Barbara Dreimiller, a local freelance writer, found herself determined to find out as much as she could about the Franklin Castle and the Tiedemann family.

Sadly, Dreimiller, a very wonderful woman, passed away on December 21, 2001. Her research notes, which Barbara's daughter, Rachel Cisar, generously made available to the grateful authors of this book, remain a valuable treasure.

It should be noted that Barbara Dreimiller's name appears in one of the castle legends. She was said to have once encountered a menacing mist on the third floor. However, her notes and her two published articles never mention such an experience, so it would seem unlikely—though not impossible—that it happened.

Barbara's first Franklin Castle article appeared on February 28, 1975, in the *Cleveland Plain Dealer*'s *Action Tab* magazine and was titled "Franklin Castle's Fright Seeing Tour." Here, she described the many disturbances within the house, including lights going on and off for no reason, rotating chandeliers, echoing footsteps and mysterious voices. She wrote that photography in the castle was challenging. Sometimes cameras would suddenly stop working. Sometimes developed film would reveal added features, like misty areas, ghost-like figures and orbs of light.

While cameras weren't allowed during tours, one could arrange a private session to try catching a ghost on film. One such photographer told Barbara that he would never come back to the house. He had been talking with one of the owners on the first floor and heard someone call his name from the floor above. When he went to investigate, he found no one there.

Barbara Dreimiller. *Courtesy of Rachel Cisar.*

A nurse said she worked the late shift in the house, caring for a prominent Cleveland attorney who lived there in the early 1930s. She stated that she would hear a dreadful noise, like a child crying, but the servants dismissed the sound as cat noises, and the family never talked about it. She, too, refused to set foot in the house again.

Barbara also noted that a recent discovery, other than bones, had been made. Located on the fourth floor was a passageway between the floors that led to an open area. The trunk room had been rediscovered. Also found in there was the image of a doll and the name "Tom Smith—1882," written and dated in an old-fashioned script.

Cleveland Landmarks Commissioner John D. Cimperman was of invaluable assistance to Dreimiller's article. He was able to indicate where certain rooms had once been. Figuring out the original floor plan would be very challenging for the average person after the Eintracht Club remodeling.

After the *Plain Dealer* article, Barbara Dreimiller rewrote and improved the pamphlet that was being used with the castle tours.

Three and a half years later, she wrote a second article, titled "A Dream of Things that Were," which appeared in the July–August 1978 issue of the *Western Reserve* magazine. Authors Richard Winer and Nancy Osborn Ishmael must have been familiar with this article, because the Franklin Castle segment in their book *More Haunted Houses* was titled "A House of Things that Were."

In her second article, Dreimiller brought to life an era far removed from our modern age. In her research, she located an eighty-four-year-old woman named Alvina Beck, the daughter of Hannes Tiedemann's handyman and gardener, Heinrich Bühning. Mrs. Beck was a nursing home resident and still had a sharp mind and an amazing recall of family stories.

She clearly remembered the excitement in the house on the day when Hannes Tiedemann returned from Germany with his new wife, Henriette.

She also recalled that Henriette was a stern mistress, actually inspecting the house for dust while wearing a pair of white gloves.

Lois Carelli, Mrs. Beck's daughter, also contributed information about birth, marriage and death dates, which had been written in a poetry book. Henriette Tiedemann had personally made some of the entries in this family heirloom. Sadly, Alvina Beck died before the article was published.

Because of its grandeur and reputation, the Franklin Castle has served as a venue to draw attention to a special cause from time to time. Consider the following example.

An article in the Sunday, April 13, 1975 *Plain Dealer* briefly mentioned that the Franklin Castle, while owned by Samuel Muscatello, was currently unoccupied and rumored to be haunted. The article's real focus, however, was on the Bail Benefit Ball to be held that Saturday at the castle.

The information regarding the ball was provided by Reverend Robert T. Begin, a Catholic priest who was the spokesman for the project. The benefit's purpose was to raise money to help indigent people who were charged with nonviolent crimes to post bail and avoid detention at the county jail. At that time, the county jail was hopelessly overcrowded. It held nearly 550 inmates but had been designed to only hold 300. This led to deplorable conditions.

Father Begin's group had already bailed out about 180 people so far, and only 25 had skipped out on the bail.

Using Franklin Castle would help draw a crowd, which the castle could handle. Ticket prices were $25 for patrons, $15 for couples and $7.50 for singles.

At this point, Father Begin should probably have gone off the record, but he didn't. He went on to say they'd be selling booze for the first time at their fundraiser and hoped they weren't busted, because then they would have to use the ball contributions for their own bail. Both Begin and the reporter, Robert Dolgan, probably thought it was a cute quote and would spice up the article.

It also spiced up the ball.

About 300 people were socializing, enjoying themselves for a good cause, on that Saturday evening of April 19, 1975. Admission was paid at the door, and while liquor wasn't technically for sale, it was available for an additional donation to the fund.

Then, around 10:00 p.m., officers in nearly twenty police cars, led by three state liquor agents, converged on the castle. Sam Muscatello said there were so many police that he couldn't count them all. He claimed he saw police push a pregnant woman and that some officers had billy clubs and

others had cocked shotguns. Tim Swope reported seeing a man hurled down some stairs. Many claimed to have been brutalized by police.

Father Begin and three others were charged with keeping a place where liquor was illegally sold and not having a dance hall permit. Six others, including a Lutheran minister, were arrested for obstructing and resisting police. Eventually, all ten were acquitted of all charges.

A couple months earlier, on February 1, 1975, Samuel J. Muscatello had been ordained a minister by the Universal Temple of Truth Foundation, a nonprofit corporation based in Dayton, Ohio, whose stated purpose was to provide a place of worship, promote the Christian faith and hold property in the church's name.

A sign for the Universal Christian Church was placed outside Franklin Castle that May, but plans to open the church weren't announced until a July 12, 1975 *Plain Dealer* article, in which Reverend Timothy Swope also stated that the house would serve as a food distribution center for the needy. Overnight house stays were also available for fifteen dollars. The proceeds would help pay for renovations.

Swope, who'd stayed ten weeks in the house by himself after it was purchased, said he would have his radio blaring at night to drown out the other sounds. He also said, "There are no evil spirits here."

In the article, Swope spoke extensively about Karen, who wasn't evil but definitely was a spirit. She would hang around the third-floor room, which had been Louise Tiedemann's bedroom and was now called the Cold Room because it was ten degrees colder than the other rooms. Since many people would find themselves accidentally locked in that room's closet, its doorknob was removed.

Dr. Hans Holzer, noted ghost hunter and prolific writer, told Muscatello and Swope, "This place was and still is haunted." He had been to the castle various times, first when it was the Eintracht Club, at which time he'd etched his initials into a third-floor windowpane, and then later when the Romano family lived there.

Connie Fleming, Reverend Swope's sister-in-law, remembered Holzer's visits. He had told her to stay out of the Cold Room, where she'd once been overcome, and to stay out of the ballroom, where she was giving belly-dancing lessons. One of Fleming's students was Eleanora Bernstein, a self-proclaimed psychic who pops up later in this book.

Connie recalled the castle being rigged with buzzers and the like around Halloween when it was opened to the public as a haunted house. She recalled many unusual experiences. There was the door to the Cold Room,

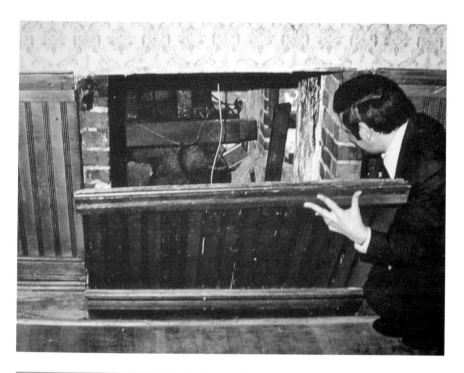

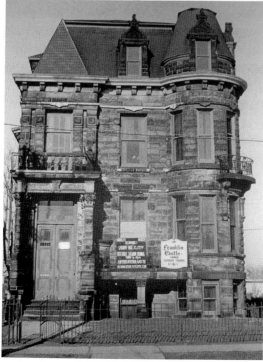

Above: A tour guide reveals the hidden room where a liquor still was discovered, circa 1975. *Courtesy of the Cleveland Public Library Photograph Collection.*

Left: Franklin Castle with signs for tours posted in front, circa 1975. *Courtesy of the Cleveland Public Library Photograph Collection.*

which—when examined closely—had the image of a face on it. She was also present when Muscatello found the bones in the wall. She said the wall was completely sealed up until Sam had cut the hole, so there was no way that he or anyone else could have planted them there.

She remembered the food distribution center on the first level of the house that was open about once a week for free meals. Meanwhile, the second level served as the hall where church services were held.

After almost twenty-one months, James and Dolores Romano ended their contract with Sam Muscatello. He had fallen behind in his payments. They believed he'd planted the bones in the wall, and enough was enough. The Romanos evicted the group from the house, and a new owner would have to be found.

On May 26, 1976, the title to the Franklin Castle was transferred from Samuel J. Muscatello and his wife, Pauline, to Roderick Aldrich Kratoville and his wife, Maryon Fay Waldman Ruchelman.

Kratoville, the building commissioner for Rocky River, Ohio, had heard stories about the castle over the years. While driving down the road one day, he saw a For Sale sign out front and inquired with the Russell Realty Company. He and his wife moved into the house that June.

During their time at the Franklin Castle, Kratoville made numerous changes to the structure. Among these were the removal of the trunk space and the opening up of the hidden room on the first floor, where the liquor still had been discovered.

In a 2007 interview for this book, Kratoville said he couldn't recall any paranormal activity in the house. Since it had been thirty years ago, the most he could remember was that it was a large house and that he didn't live there very long. As it turned out, he wasn't married to Maryon very long either. They divorced, and Roderick Kratoville moved to Texas, where he passed away on March 21, 2007, just weeks after the interview.

His ex-wife, Maryon Ruchelman, wouldn't live in Franklin Castle very long either. The castle was back on the market, but there would be a surprise announcement. This announcement appeared in Mary Strassmeyer's column in the June 6, 1978 issue of the *Plain Dealer*, under the title "His Home Is His Castle." Mary reported that Richard Duane Hongisto, the former Cleveland police chief, and his wife, Elizabeth, had purchased the Franklin Castle.

This was big news, because everything about Hongisto for the past seven months had been fodder for the local and national media. He had resigned as sheriff of San Francisco to accept the job of Cleveland police chief. He

had been hand-picked by Mayor Dennis J. Kucinich, who installed him on December 14, 1977, suspended him on live television on March 23, 1978, and fired him the next day. In between all that, Hongisto returned to San Francisco to marry Elizabeth L. Colton on February 12, 1978. They took up residence at 3021 Keswick Road, near Shaker Square.

Strassmeyer's article mentioned $80,000 as the original listing price for the castle, and Hongisto said that he didn't pay quite that much for it, but close. He went on to say they had no plans to convert it into apartments. They would simply live there, beginning in July. The couple liked to entertain, so the castle seemed ideal.

As a result of Strassmeyer's article, Richard Hongisto will be forever a part of the castle's history, even though he never actually lived there. The article was premature. No record of the transaction can be found at the Cuyahoga County Recorder's Office—and for good reason. As they were about to finalize the purchase, Hongisto accepted the job as director of the New York State prison system. That position would also prove to be short-lived. Hongisto later returned to San Francisco, where he died on November 4, 2004.

Richard Hongisto's ex-wife, Elizabeth Colton, was contacted for this book and recalled some of the events surrounding their involvement with the Franklin Castle but was unaware that she and her husband had ever been mentioned in so many books written on the house.

"When Dick and I were living in Cleveland, we went through a time when we were very interested in buying a house," she remembered. "I believe we simply saw a 'For Sale' sign on the house, but I may not have all the facts there. We were of course very intrigued by the Franklin Castle because of its unique and stately style."

The house would soon find a new owner, but it wouldn't be a former chief of police.

HIGH ASPIRATIONS

On December 22, 1978, Maryon Ruchelman sold the Franklin Castle to George J. Mirceta for the sum of $85,000. Mirceta had been viewing properties in the area with a real estate agent, and the house seemed ideal.

When Mirceta moved into the house, it was in a state of disrepair. The large room on the first floor that was once the servants' dining room and parlor had been divided up and converted into apartments. Also, the motor for the dumbwaiter was missing. George planned to restore the house to its original condition. Seeing that a full restoration would be too costly, he tried to secure funding from the state but was turned down, as funding wasn't available.

Around that time, George applied to have the house added to the National Register of Historic Places. The house's background first needed to be reviewed.

In 1980, a familiar face returned to the Franklin Castle, that being the self-proclaimed psychic who'd once taken belly-dancing lessons with Connie Fleming on the fourth floor, Eleanora "Ellie" Bernstein. Ellie claimed to be the girl that appeared on packages of Sunbeam Bread, having won a contest as a child. This claim has never been proven. Regarding her psychic abilities, these she claimed stemmed from early childhood when she had a premonition of her father's death, which occurred the following day.

Years before her involvement at the Franklin Castle, Ellie claimed to see a figure of a woman in one of the upstairs windows. She also said that she'd occasionally go into a trance in the middle of the night and wake up to find

a story about a member of the Tiedemann family written on the paper in her typewriter. From there, she'd go to the courthouse and look up records on the family. Much to her astonishment, these records seemed to match up with what she had written, or so she claimed.

When Ellie Bernstein returned to the Franklin Castle, she was given a room and took on the duty of giving tours. She also continued to write about the early ownership of the house. It's from these writings that many of the current legends about the house can be traced.

In an article that appeared in the *Cleveland Press* on March 27, 1980, Ellie claimed that the ghost of Hannes Tiedemann was telling her about his life in the Franklin Castle. She claimed that he passed through her room on many occasions and referred to her as Anita. All of this she was writing in a book she planned to call *The Haunting of Franklin Castle*.

In her journal, she told of how Tiedemann had gagged and tied his mistress, a girl named Rachel, to a bed. He later shot her the day she was to marry another man. Ellie claimed that the walls of the room still echoed with the sounds of Rachel being choked and many people reported seeing a slender woman dressed in black. She also mentioned a rafter in one of the passageways that surround the ballroom and claimed that Hannes Tiedemann hanged an illegitimate daughter named Karen after finding her in bed with one of his grandsons. Bernstein went on in the article to talk about the human bones that were discovered by Sam Muscatello; she was convinced that there were more in the backyard, where she planned to excavate later that spring. Needless to say, no further human remains have been found on the property.

George Mirceta and Eleanora Bernstein 1980. Bernstein is holding her book *The Haunting of Franklin Castle*. Photo by Tony Tomsic. *Cleveland State University Library*.

As near as anyone can find, Ellie Bernstein was the first person to accuse Hannes Tiedemann of murder, a falsehood that has endured to this day.

Other articles were written during that time. One quoted George as saying that if the house really was haunted, he wouldn't be living there. Another stated that he heard a baby's crying coming from within the walls of a third-floor bedroom. He never was very clear on his belief in the haunting and always left that as something of a mystery.

In 1981, a psychiatrist named Ron Balas opened a center in the house called Kids in Crisis, a program to help troubled teens that was funded primarily through donations. The program operated for about a year before Balas was asked to leave for not paying his rent.

It was also around that time that George met his wife, Helen. This occurred when she happened upon the house and took a tour. Looking back on the stories that were told about George hearing a baby's crying, Helen never recalled hearing such a thing. She did, however, occasionally hear the sound of a window opening and slamming shut, followed by the sound of glass breaking. Fearing that vandals were damaging the houses that stood on either side of the Franklin Castle, she and George investigated one night to see if this was the origin of the noise. As it turned out, both neighboring houses were perfectly fine.

As far as any other disturbances went, Helen recalled that she'd see a short, stocky woman walking past her with her hair up in a bun and dressed in black. Helen further recalled being pushed a couple of times while coming down from the third floor, as well as many instances where items would move about on their own. Something would be put down, and by the next morning it would be somewhere else.

One night, George and Helen set up a tape recorder in an upstairs room and decided to let it run. They came back to retrieve the recorder and played back what it had captured. The results were incredible.

They heard the sound of an older man's voice occasionally joined by that of a younger woman's. They heard the sound of slaps, screams and the man occasionally yelling. One thing was certain. The language being shouted wasn't English.

One story that George related to Helen, which occurred in the house before they'd met, was of a tour that had been given to a family one afternoon. Accompanying this family on the tour was their young daughter, who wandered off at some point early on. At the conclusion of the tour, the girl was nowhere to be seen. After searching the house, she was finally located sitting on the steps near the fourth floor with a blank expression on her face. Her parents, relieved that she'd been found, told her it was time to go, but the child would not move. The concerned parents finally picked her up and left.

After a few days, the family returned and explained to George that the little girl wouldn't talk, eat or do anything at all. Believing that she was somehow traumatized by something from the house, the parents told George that he had better do something about it or face legal action. At this, a priest was called and a blessing performed on the child. Almost instantly, the child recovered. It'd later be related to Mirceta that the girl had witnessed a short and stocky woman stepping out of her body.

Something that fondly stuck out in Helen's memory was the building of what she referred to as the "Berlin Wall." George had unearthed a number of sandstone blocks in the backyard, likely left over from the house's construction, and used these to build a large stone wall along the western border of the property. Part of this wall still exists today. Among the stones unearthed was a piece that had a face ornately carved into it. This matched the grotesques that are found on the front of the house but was slightly damaged. Most likely, it was to be a part of the original construction but was damaged while it was being carved and ended up being discarded with the rest of the leftover stones. The Mircetas took this stone with them when they ultimately moved out. Unfortunately, it was stolen some years later.

Finally, on March 15, 1982, the Franklin Castle received the prestigious recognition it deserved. On that date, the Hannes Tiedemann House was approved and added to the National Register of Historic Places as no. 82004417. It was added primarily because of its architectural significance, mostly to do with its builders Cudell & Richardson. Again, George Mirceta applied for a grant to help finance the renovations, but again, funds weren't available and his request was denied.

Also, in 1982, the Franklin Castle made its big-screen debut. The Francis Ford Coppola film *The Escape Artist*, which starred Griffin O'Neal, Raúl Juliá, Desi Arnaz and Teri Garr, was being filmed in Cleveland. It should be noted that while the exterior of the Franklin Castle was used in this film, the scenes of what took place inside the castle were actually filmed in a Los Angeles studio.

After filming was complete, the landmarks commission added an inscription to the transom window above the main entrance that read "Franklin Castle, built 1860, Historic Landmark." Unfortunately, the date was incorrect by more than twenty years.

Eventually, giving tours of the Franklin Castle got to be too much, and they soon came to an end, primarily due to people stealing items. Furthermore, George and Helen were now expecting a child, and the house didn't feel like the right atmosphere for raising children. The

Mircetas never got much peace living in the house. People would come in the middle of the night to ask if the house was haunted. Also, the carriage house had been broken into a few times, as had the front door of the castle itself. Helen's car had been vandalized, and windows on the servants' level of the home had been smashed out.

In short, it was time to move.

Looking back, Helen Mirceta felt that George truly loved the house. Both his heart and soul were in it, but it was time to move on.

On September 9, 1983, the Franklin Castle was sold to Richard J. Perez and his wife, Virginia. Perez was a Cleveland attorney who was already living in Ohio City on Franklin Boulevard. He'd tried to purchase the house from George Mirceta at least once before, though at the time, George wasn't ready to part with it.

After moving in, Perez did very little to change the house, as George Mirceta had done such a nice job with his renovations. Mirceta also rewired the house during his tenure, just as James Romano had.

As had happened with previous owners, the Perez family was also visited by a number of people interested in the house. One of these visitors was Sam Muscatello. According to Perez, Sam used to hold séances in the house and approached him about possibly holding another. Also around that time, Perez was contacted by The Ghoul, a local late-night horror movie host, about filming an episode of his show there.

Being familiar with the stories about the Franklin Castle, Virginia Perez decided to investigate and find out for herself if any of these stories were true. She worked as a reporter and therefore had better access to historical records than most. Her findings proved that many of the legends about the home, especially those relating to the Tiedemanns, were not true.

In all regards, the period concerning the Perezes' ownership of the house could be considered uneventful, though it's probably best to look on that time and realize that the house was, in fact, serving its original function as a private residence. Be that as it were, the home did play host to many parties, as Mr. and Mrs. Perez held many gatherings there. So maybe it wasn't such an uneventful period after all, just one that was more low-key than others.

Though they greatly enjoyed the home, the Perez family occupied the Franklin Castle for just over two years, selling it to a friend in November 1985.

15

THE THEATRICAL PROMOTER

M ichael DeVinko was born in Garfield, New Jersey, on September 24, 1934. Growing up twelve miles west of New York City, perhaps young DeVinko never had a chance. The bright lights, glitz and glamor beckoned. During the 1950s and 1960s, he was using the name Mickey Deans and had a career as a piano player and singer in the New York City nightclub scene. He also took his show on the road to Los Angeles, Reno, Miami and the Virgin Islands.

Mickey met entertainer Judy Garland on March 10, 1967, when he delivered some pills to her at the St. Regis Hotel at 5:30 a.m., and a relationship developed, as she would show up regularly at Arthur, the trendy nightclub where Deans was the manager. In December 1968, they flew to London, where Judy performed at the Talk of the Town cabaret. They were wed at the Chelsea Registry Office on February 11, 1969. It would be DeVinko's first and only marriage and Garland's fifth and final one.

By this time, they were living in a small six-room mews house at 4 Cadogan Lane, in the Belgravia district of Chelsea in London. It was there, on Sunday, June 22, 1969, sometime between 2:30 a.m. and 4:40 a.m., that Judy Garland died in the upstairs bathroom. Her husband would not discover her body until almost 11:00 a.m. "An accidental death by an incautious overdose of barbiturates," the pathologist stated.

DeVinko was listed on the death certificate as "an Artiste's manager." Some of Judy's family and friends wished that he had done a better job in managing to keep her alive. He did manage a wonderful send-off. Over twenty-two thousand people filed past her open casket during a twenty-

four-hour wake. Following the funeral, the remains of the forty-seven-year-old actress were placed in a crypt at Ferncliff Cemetery in Hartsdale, New York, where they remained for forty-seven years. On Friday, January 27, 2017, she was reburied at the Hollywood Forever Cemetery in California. A family spokesperson stated, "When Judy Garland died, her affairs were controlled by her husband, Mickey Deans. Her children had no say in the matter of her burial, so this is at last their opportunity to do what they feel their mother would have wanted in the first place: to be united with her family in Hollywood."

In 1972, Mickey Deans, with the help of a ghostwriter, wrote a tell-all biography of Judy Garland titled *Weep No More, My Lady*. It was believed to be self-serving and highly suspect in some of its revelations.

Back in New York, DeVinko went to work for Roy Radin, owner of Roy Radin Enterprises, which booked multiple vaudeville revivals and police union benefits across the country. It was later revealed that in some cases, only a small portion of the profits went to the charities they were to benefit.

The vaudeville shows featured older comedians like Milton Berle, George Jessel and George Gobel, who once said, "Roy Radin knows as much about show business as a pig knows about church on Sunday."

On June 10, 1983, Roy Radin's bullet-riddled body was found sixty-five miles north of Los Angeles, after he was missing for almost a month. Finally, in 1988, four people were arrested for the crime and were convicted in 1991. It was called "The Cotton Club Murder" because it supposedly involved a dispute over potential profits from the movie *The Cotton Club*. The film, which was Radin's attempt to get into the movie business, was a critical and financial flop.

In the wake of Radin's death, his protégé Michael DeVinko came to Cleveland to manage the company's Ohio interests. Since he would need a residence that would reflect and enhance his persona, he bought the Franklin Castle from Richard and Virginia Perez on November 22, 1985, for $93,000.

After moving in, DeVinko added a series of dummy walls that didn't quite reach the ceilings. He covered the beautiful hardwood floors with linoleum tile and the stairs with carpeting. A florescent-pink hot tub was installed on the third floor. The beautiful brick driveway was covered up with gravel. A doorbell, with a recorded message that said the house was no longer open to uninvited *human* guests, was installed to amuse visitors and curiosity seekers alike.

Judy Garland and Mickey Deans at their wedding reception in 1969. Photo by Allan Warren. *Courtesy of Wikimedia Commons.*

Still, Michael DeVinko went along with the stories of the haunting and often told of his own unusual experiences. Others, like DeVinko's friends Robert Kokai and Allen Christopher, had their own experiences. Robert and Allen were late-night horror movie hosts of *The Frank and Drac Show*. In 1987, they aired an episode about the Franklin Castle that included an extensive interview with Dolores Romano.

Robert Kokai recalled that they were both pretty much mainstays at the house from July 1987 until DeVinko sold it. He said that the house was

extremely haunted and the first time they visited, it was so active that it made the house in the film *The Haunting* seem tame. Many people reported seeing a woman in black. Robert, however, saw a woman in white that followed him around for about six months. Others were said to have witnessed her presence in three different locations in the house.

Michael DeVinko claimed to have located many items once owned by the Tiedemanns, including an original house key, some furniture and the original blueprints for the castle. The blueprints, which he claimed to have tracked down from a firm in Nova Scotia, turned out to be the plans from when a group in New York City had tried to buy the house from Mrs. Romano and move it to the East Coast. Jimmy Romano distinctly remembered that his mother gave those blueprints to DeVinko. The Romanos also returned the stone lions.

Jimmy Romano further recalled that DeVinko would often go on, in his thick New Jersey accent, about how he had been married to Judy Garland, drove Lincoln Continentals and how he did whatever he wanted, usually lacing these comments with coarse language.

The blueprints, furniture and other items that DeVinko claimed to have acquired will always be a mystery, since they were supposedly stored next door in the carriage house behind the old Wiebenson home. In the late 1980s, the carriage house and its contents were destroyed by a fire.

One of DeVinko's more extravagant claims was that he'd spent $1 million in renovating Franklin Castle. Many of those who knew him believed this to be an exaggeration.

In 1987, Michael DeVinko formed a company called Olympian Productions Inc. Its stated goal was to raise money for the Cleveland Police Patrolman's Association, as well as the National Black Policeman's Association. While DeVinko would hold an occasional fundraiser at the Franklin Castle, the main solicitation was done by telemarketing. This business was listed at the castle into 1999.

Assisting Michael with Olympian Productions was a dear friend and companion named Richard Driscoll, whom he often referred to as his son. Described as a fairly quiet man, Driscoll lived at the Franklin Castle in 1987 and again from 1991 until 1995, when he moved into the old Wiebenson house, which was also owned by DeVinko. At one point, that house was extensively outfitted with phone banks, computers, cables and wires to serve the telemarketing business.

Another houseguest at the castle during the late 1980s was Jeff Romano. James and Dolores Romano's youngest son always felt a close connection to

the house because it held many fond memories of his late twin brother John. Jeff and his friend Chris Manacapelli stayed there for a brief time, but they soon became uncomfortable and left. Their discomfort had nothing to do with the paranormal. It had to do with DeVinko and his wild lifestyle.

Over the years, DeVinko's extravagant parties were of legendary dimension. People from all walks of life attended, especially around Halloween. A couple of the more notable visitors to the house were Phil Specter and Elvira, Mistress of the Dark.

Finally, in 1992, Michael DeVinko put Franklin Castle on the market for $795,000. There were no takers, so the sale price slowly moved to an amount someone would pay. In 1999, DeVinko, in declining health, put the Franklin Castle in his rear-view mirror and moved to Northfield, Ohio.

Sixty-eight-year-old Michael DeVinko died of congestive heart failure at the medical center in Sagamore Hills, Ohio, on Friday, July 11, 2003, and his ashes were shipped to a friend in Florida.

16

ON THE BRINK

When Michelle Ann Heimburger was five years old, she and her family moved to Lakewood from Hartsgrove, Ohio. Her mother loved art and architecture, while her father, Allen, was interested in the paranormal. One day, the Heimburgers were driving down Franklin Boulevard admiring the houses. When they were stopped at a red light at the corner of Franklin and West 44th Street, Allen Heimburger, knowing the castle's colorful past, told his daughter to look up at the windows and see if she could see the lady in black. Michelle was hooked. From that day on, she swore she would someday own that house.

In the years that followed, the family moved around the area quite a few times. Still, Michelle never forgot about the beautiful home in Ohio City or the promise she made to herself. After graduating from high school, Michelle attended Bowling Green State University, where she received degrees in literature and art history. After graduating from college in 1996, she was contacted by a friend who had just taken a job with a new web company in California called Yahoo! and informed her that they were hiring. Michelle traveled to San Francisco, where she interviewed for a job with the company. Upon her return to Ohio, she learned that the company wanted her. Michelle Heimburger became its 100th employee.

In early 1999, Michelle's cousin contacted her to tell her that the Franklin Castle was again up for sale. Considering her new occupation and knowing that there was much security in this new industry, she realized that the time had finally arrived for her to actually achieve her childhood dream. In early

April, Michelle and her father toured the magnificent stone mansion. Upon the conclusion of this tour, Michelle offered the sum of $350,000, and on April 14, 1999, Michelle Ann Heimburger became the Franklin Castle's eleventh owner.

One month later, Michelle threw a large castle-warming party that included a rock band playing in the fourth floor ballroom. A professional photographer was flown in from California to document the event, and the hundreds of guests were encouraged to explore the house. Shortly afterward, renovations began.

The first thing to go was the pink hot tub on the third floor, followed by the short bar that had been installed as a replacement for the larger one on the third floor. The linoleum tile and carpeting on the stairs were also torn up. Finally, the dummy walls that Mr. DeVinko had added were torn down. Michelle planned to restore the house to its original glory and use it solely as her residence. Still, the idea of later converting it into a bed-and-breakfast was not entirely ruled out. As to the idea of opening the home to paranormal investigators, that was out of the question.

Keeping her job in California made it nearly impossible for Michelle to stay in Cleveland for any extended amount of time. Restorations were being done little by little, whenever she had a chance. Still, that October saw one of the best Halloween parties that Cleveland had seen in many years. Again, more than four hundred guests were treated to an extravagant evening in Cleveland's most notorious haunted house. Sadly, among the guests were many party crashers. It's believed that one of these party crashers unbolted the back door. This was something that would haunt Michelle for many years to come.

One week later, on November 6, 1999, a twenty-nine-year-old man staying at St. Herman's House of Hospitality, just west of the Franklin Castle, entered through that unlocked back door and set a fire near the first-floor boiler room. The fire quickly spread and traveled up the dumbwaiter shaft, where it burned through the fourth floor. Firefighters arrived shortly after 11:00 p.m. and had the blaze under control in about an hour. The arsonist was located on the first floor. He smelled of alcohol and was incoherently rambling of two other men being with him, though no one else could be located. He was transported to MetroHealth Medical Center, where he was treated for first-degree burns and smoke inhalation. Afterward, he was released into police custody and charged with aggravated arson and aggravated burglary. He was found guilty and sentenced to five years' incarceration.

Coal room on the first floor of the Franklin Castle, where the 1999 fire was started. *Photo by William G. Krejci.*

Damage estimates were placed between $200,000 and $500,000. Michelle enlisted the services of the architectural firm Robert Maschke and Associates, and repairs began. The Infinity Construction Company was contracted to handle the massive workload of this restoration, and by the summer of 2001, all of the charred debris had been removed and the mansard roof replaced. During these renovations, some of the damage the house received from the tornado of 1953 was corrected. A new sandstone gable was installed on the southwest corner of the home, and the top of the tower once again came to a peak.

The fact is that Michelle Heimburger loved the Franklin Castle from the first moment she saw it. After the fire, she was completely devastated. It began to look as though her plans to finish the home weren't going to be realized. Then, in 2003, a new person emerged, one who looked to be able to complete the work that she started.

Thus arrived Charles Milsaps, real estate developer and owner of Milsaps Properties of Lakewood. Milsaps approached Michelle with an offer to purchase the house for the sum of $650,000, to which she agreed.

Milsaps's plan for the house was to convert it into the Franklin Castle Club, an exclusive members-only club, catering to downtown businessmen, the wealthy and newer residents of the neighborhood who wished to join an urban club rather than a country club. His earliest estimates put a price tag of nearly $3 million on the renovations.

New plans called for a first-floor, eight-thousand-bottle wine bar and a second-floor sixty-four-seat dining hall. The third floor would be converted into the club lounge, and the fourth would become a banquet and meeting room with seating for about eighty. Within the first few weeks of the announcement, Milsaps claimed to have already sold fifty memberships, with the intention of selling a total of five hundred. A one-time membership fee of $5,000 was required, along with a $200 monthly maintenance fee to be spent at the club on meals, drinks or overnight stays.

Almost immediately, friction arose between Milsaps and Ward 13 councilman Joe Cimperman, son of John D. Cimperman, the former Cleveland landmarks commissioner who'd assisted Barbara Dreimiller with her first article on the Franklin Castle. Councilman Cimperman's concerns were that the neighborhood was primarily residential. He was certain that the project would require zoning variances for parking and other matters to meet the demands of the neighborhood.

Unfortunately, the Franklin Castle Club never came to fruition. By 2005, very little work had been done on the home since Charles Milsaps took over the property and moved into the carriage house. It was during that time that Haunted Cleveland Tours, operated by Chuck Gove and Beth Richards, was making regular stops at the house. Tours were given of the home but were limited to the first and second floors, the third and fourth floors being in too poor a condition to allow guests.

The following year, an article appeared in the *Cleveland Plain Dealer* titled "New Strange Doings at Franklin Castle." Reporters Michael O'Malley and Joan Mazzolini uncovered more of Charles Milsaps's involvement with the house. Through a website, Milsaps billed the house as a members-only social club, though the club still didn't exist. His claim on this site was that the club featured fine dining, overnight stays, twenty-four-hour limousine service, a Florida beach house called the Sand Castle and a seventy-two-foot yacht called the *Sea Castle*. The beach house, he would later say, was actually owned by his parents, and while the yacht pictured on his website was not the actual yacht, he claimed that one was owned by relatives. Furthermore, it was now learned that Milsaps was not a real estate developer at all, as he owned no properties. As to the fifty memberships that he claimed to have

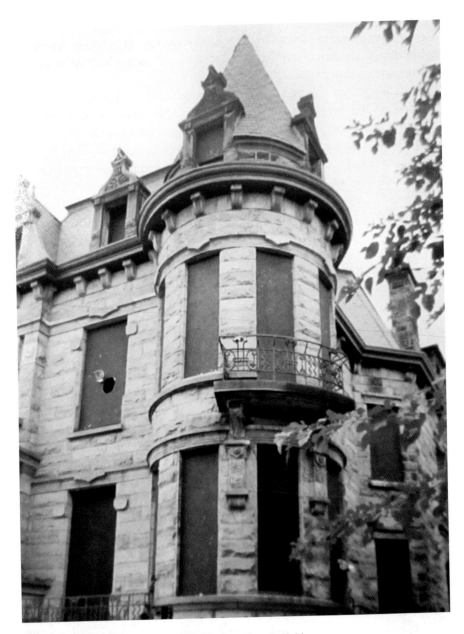

Franklin Castle boarded up in 2006. *Photo by William G. Krejci.*

already sold, that also was not true. He now recanted his previous statement, saying that fifty memberships had been "reserved" might have been a more appropriate comment.

Councilman Joe Cimperman stated in this article that he was highly opposed to the proposed club. Listening to the concerns of neighbors, especially the group that operated St. Herman's House of Hospitality, Councilman Cimperman vowed to block a liquor license for the club.

At the time this article was released, two contractors were attempting to collect money from Milsaps. The Cleveland Lumber Company had placed a lien on the property, claiming $1,650 in unpaid lumber bills, and interior designer Chris Demkow had just won an $11,500 judgment against Milsaps for renovations done in the carriage house, where Milsaps had been living.

The house continued to fall into further disrepair. At one point, a sewer line ruptured in the southeast corner of the house, ruining the floor of what had once been the servants' parlor. Milsaps decided to remove the entire floor and take everything down to the dirt base beneath. Unfortunately, this

Descendants of Hannes and Louise Tiedemann visit the Franklin Castle in 2006. *Left to right:* Kari Jonassen Tiedemann, Carla Wiebenson Henebry Branscombe, Carl Hans Tiedemann II, Art Branscombe, Anne Wiebenson Hammond and Dora Louise Wiebenson. *Photo by William G. Krejci.*

was not limited to the former parlor, but rather was done in every room on the lowest level. Further damage continued on the upper floors. Windows on the fourth floor, in what had once been the back bedroom, had not been covered properly. The house was now overrun with pigeons, their droppings covering the floor in piles as high as six inches. The future of the Franklin Castle looked bleak.

In 2006, the descendants of Hannes Tiedemann were made aware of the condition to which their ancestors' house had fallen. A trip to Cleveland was coordinated by Dora Louise Wiebenson, a great-granddaughter of Hannes and Louise Tiedemann. Accompanying her on this trip were her first cousins Anne Hammond and Carla Branscomb and a second cousin, Carl Hans Tiedemann II. A tour of the Franklin Castle was arranged with Michelle Heimburger, though they were met with some friction by Charles Milsaps at the gate. Ultimately, he admitted them and proceeded to walk them through their ancestral home.

Following this tour, the descendants of Hannes and Louise Tiedemann expressed much disdain regarding the state to which their great-grandparents' house had fallen. Carl Tiedemann had, at this point and for some time after, considered purchasing the house outright and restoring it by his own means, but that plan was ultimately abandoned.

Due to the fact that very little work had been done on the house, as well as the fact that Milsaps wasn't living up to his end of their agreement, Michelle Heimburger decided that she would seek a new owner. On March 21, 2011, as Charles Milsaps was in the process of moving out, the carriage house where he'd been living was set on fire by an arsonist. Fortunately, most of his belongings had been removed, and he was not at home at the time of the fire.

With luck, a new owner would realize Michelle Heimburger's original dream—to see the house restored to its former glory.

17
A NEW BEGINNING

Sometimes reality surpasses the wildest fiction. Sometimes people are just instruments of destiny and events that seem highly unlikely unfold into a perfect dénouement. To the confused actors, the play only makes sense in the final act.

Chiara, or Kitt to her friends, was born and raised in Venice, Italy, where she hails from a family whose first written records go back to the year 1090. Her family, of Roman origins, was previously established in the ancient city of Aquileia. When Aquileia was destroyed and set fire by Attila and his Huns in 452, the survivors took shelter in the nearby lagoons, thus establishing the city of Venice. The family participated with three galleons in the Battle of Lepanto in 1571, a famous naval engagement against the Ottoman Empire. As Venice had been a very small city with a worldwide influence, it was not uncommon for Venetians to travel for years and find their destiny around the world. Sometimes, kids would embark on their eighth year of life—the age they first receive Holy Communion—and later return either beaten up by a life of adventures or blessed by glory. Kitt would be no exception to this.

A contemporary Renaissance lady, she studied and practiced literature, music, architecture, ethnology, design and painting. A lifestyle icon and muse to artists, she also collects ancient fabrics and objects whose inspiration comes directly from ancient European paintings. As a Venetian aristocrat raised by the English, she was trained at a young age to pursue passions with discipline and high standards of quality and dedication. As a decorative arts

editor, she would make regular visits to her designer clients and distributors in their showrooms.

This gave her an opportunity to pursue her favorite occupation. Kitt has a true love of collecting 1950s and 1960s rhythm 'n' soul, rock 'n' roll, garage, psychedelic and exotica seven-inch vinyl records. She's been particularly obsessed with obscure garage bands from Pennsylvania, Michigan and Ohio since discovering the *High in the Mid-Sixties* record compilations at the Milan flea market at sixteen. Those compilations included LP volumes for each state. Fate handed her a wonderful and poignant Ohio compilation of unknown teen garage bands. Chance would place the Franklin Castle on her path in a similar way many years later.

During a trip to hunt down design deals for her business and locate more obscure records, she found herself in Cleveland and met some likeminded friends who dreamed of starting a record-hop night, like those once held in the 1960s, in the times of the Mad Daddy, Ghoulardi and Mike Metrovich from Pittsburgh, Pennsylvania. Kitt joined Erin and Josh Ryan's monthly dance night at the Five O'Clock Lounge, called Shake It Up and Move, as a resident DJ, with fervor. The night picked up steam and soon became a success. On the other side of the city, Mark Leddy, Kristin Garageland and Eileen and Tom Fallon of the Alarm Clocks and many others had been working for years to establish Cleveland's authentic musical renaissance.

As time passed and ideas thrived, Kitt grew fond of Cleveland's untamed spirit and started looking for a space that could shed light on the 1950s and 1960s American aesthetics and musical explosion. She wished to create a shrine for music, a space that could be used to host musical events.

The idea was to have something that could be the opposite of a Hall of Fame, a Hall of Obscurities, so to speak. In this space, she could host cinema nights, record listening parties and record hops, concerts, events and world-class guest curators in a museum dedicated to the underground music culture. Cleveland seemed to be an exciting beehive of cool happenings with groups such as Tom Dechristofaro (DJ Allright) and Dave Petrovitch's (DJ Partysweat) Secret Soul Club and the internationally renowned shows at Marc and Cindy's Beachland Ballroom, the Happy Dog, Mahall's and Now That's Class. Such a space as she was hoping to establish seemed to be a perfect fit for Cleveland.

While looking for such a property with her real estate agent, Michelle Anderson, they drove past the Franklin Castle numerous times, but when Kitt inquired about it, Michelle informed her that it had a colorful past and wasn't exactly available. Finally, on Kitt's last night in the United States

before returning to Europe, Michelle revealed to her that the Franklin Castle might very confidentially be for sale.

The next morning arrived as a bright and sunny day. With only a little time to kill before Kitt had to board her plane, she and Michelle visited the Franklin Castle. It was a superb and radiant house. It was so hauntingly *Hammer Films* on the outside and yet so warm and cozy within. Something that really drew her to the house was the fact that it was designed by Frank Edward Cudell and John Newton Richardson, two architects she had studied while working on her degree in architecture in New York. Kitt, as has been the case with so many others who came before her, immediately fell for the house as if she were under a spell.

Aside from the historical prominence regarding the house's architects, she also found herself attracted to the endearingly primitive carved wooden details of European folkloric iconography located throughout the home, as well as the many original pieces of Eastlake hardware. Kitt also enjoyed the very contained European proportions of the rooms. She found it to be a very well-designed plan with extremely intelligent dispositions of the rooms and spaces. After quite a few animated working meetings with her partners, Kitt was able to convincingly demonstrate that the project had a promising future and successfully secured the means for buying the house. The Franklin Castle was purchased from Michelle Heimberger on August 18, 2011, through the limited liability company Oh Dear! Productions, LLC.

The house was considerably gutted but still very solid, with its exterior sandstone walls and double-brick wall system inside. She was charmed to discover that stone keys from the exterior walls locked into the interior bricks, adding stability to the structure and creating a void where air could act as an insulator. She was astonished by this and other little tricks that were used in the construction. It was discovered that the wainscot paneling and casements were locked into the brickwork with pegs, thus eliminating the need for nails and allowing the wood to breathe with the rest of the house. When renovations started, it seemed like a daunting task, but luckily, Kitt was not alone, as she had friends like Sarah Hollander and neighbors like Richard of the Gables, who had gone through a similar restoration.

It was around this time that Kitt met Pascal, another European, who hailed from Gdańsk, Poland. Both share a love for 1950s and 1960s underground music. Aside from being a librarian, Pascal is also a singer, guitarist and composer, having been in Les Radiations, Whodunit, the Norvins and Les Darlings, his current band. He and Kitt were booked to play records together in Paris and were deeply in love to a point where Pascal decided to join forces

in this formidable adventure. Kitt needed this resourceful, handsome and ingenious man, who came to her rescue while she was absolutely crushed by the restoration of the house. To her, he was the prince charming of her dreams. Pascal was the first one who was able to stay for weeks alone in the castle, at a time when it was still in a state of ruin. He wasn't afraid. Kitt attributed this to his great sense of humor and rationality. To every problem that came up during the restoration, Pascal had an answer. The carpenters got used to hearing him say with regularity "If there is no solution, it means there's no problem." If there truly was, though, both he and the carpenters would have a race to find the best solution.

Another part of the team is Rusty, the 1979 Ford F-100 custom pick-up truck that Pascal purchased out in the country. Used for hauling construction materials to the castle and as their mode of transportation in Cleveland, Rusty eerily sits in the backyard while Kitt and Pascal are in Europe. He too has become a part of the castle's growing legend. Not only does Rusty look very spooky sitting at the end of the driveway, but it is also believed to be haunted.

The turning point in the project was a meeting with a brilliant city supervisor named Edie Sugar. It was Edie who brought in Master Byler, an Amish craftsman from a company called Cherokee Construction. He, his two sons Bill and Wally and their friend Chris impressed the team with their work ethic and efficiency. Another person who was a key player early on was Robert Johnson, a phenomenally strong man, who helped in the most difficult phase of the restoration and kept the premises secure. Brian of Gibbs Electric completed the team. If there was anything good to come of the fire in 1999, it was the fact that the ceilings were so badly damaged that the rafters were now accessible and the house could be properly rewired.

Kitt and Pascal's plans for the restoration of the house were to bring it back to its original glory and have it emulate the way it looked when it was first completed in the early 1880s. They wished to present it as a time capsule of that era, with candlelight, chimneys and no signs of modern amenities. Their plan called for only a few electrical outlets, which would have been needed for a movie projector and record turntables. Unfortunately, the City of Cleveland wouldn't allow this. The house needed to comply with modern building codes. Personally, Kitt dislikes drywall and modern building materials, but codes are codes and the laws needed to be adhered to.

Aside from this, the city also ordered the coal room on the back of the house to be demolished, as they claimed it was beyond repair. Another change that needed to be made was the addition of a fire block separating

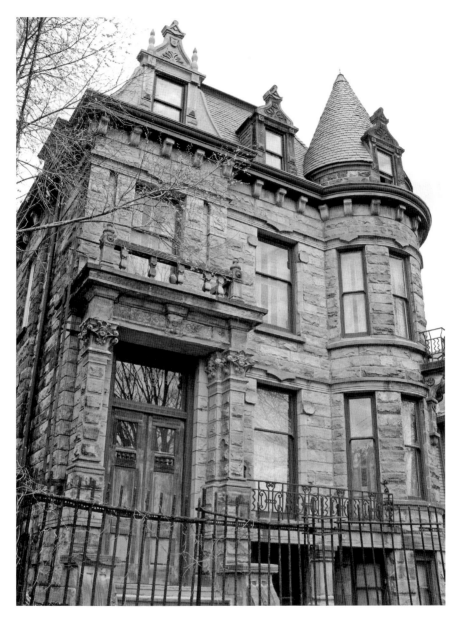

The Franklin Castle after exterior renovations, circa 2016. *Photo by William G. Krejci.*

the third and fourth floors. At this, a barrier was placed in the stairwell, the historic musicians' gallery was removed and a door was installed on the landing.

In the summer of 2015, while installing underground mains across the backyard, the contractors uncovered a stone foundation that seemed to present a new mystery. After further excavation was done, it was determined that they had uncovered the foundation of Bachelors' Hall, which had been hidden for over 134 years. After the sewer line was laid, the site was covered and preserved.

It's hoped that the city will allow Kitt and Pascal to open a museum of curiosities with guest collections from all over the world and host monthly movie and oldies nights, special events and small concerts by likeminded bands. Another project in the works is a furniture line that will be available through the Franklin Castle's website. This is being done in conjunction with the Amish carpenters who are working on the restoration of the house. The line will be inspired by the castle's original decorative arts influence of northern and eastern European and Saxon crafts and folklore styles.

By the spring of 2017, a majority of the renovations were complete. The house now contained new parquet floors of white oak and black walnut, restored antique cast-iron radiators and ceiling details. What could be saved after the fire of 1999 had been saved. Where details were completely destroyed, new ones in the same vein were added. Later plans call for reconstructing the carved wooden porte-cochère over the side entrance and the complete restoration of the carriage house. It's hopeful that the restoration of the Franklin Castle will be completed by the fall of 2017.

One burning question that has been on nearly everyone's mind is to know if the house will one day be opened again for tours. The answer to this is yes. Once the renovations are complete, reservations for small tour groups will be accepted.

Kitt and Pascal's wish is that the Franklin Castle will be the destination of choice for anyone wishing to view a Hall of Obscurities, dedicated to lost and obscure musical gems of American subcultures of the 1960s. Of course, they also hope it to become a destination for anyone interested in ghosts and the mysteries of the occult. After all, it's also a haunted house.

18

AND IN THE END

So there you have it, the true story of what has come to be known as the most haunted house in Ohio. Looking back on the colorful history of the Franklin Castle, we've separated myth from fact regarding the Tiedemann family, who first occupied this amazing structure, and straightened out the stories of those who followed. Some legends have been debunked, while new ones have come to light. Long-forgotten owners have been remembered, and the lost faces of those who dwelt within the castle's walls have emerged from the shadows of the past.

And so here ends this narrative of the history of the Franklin Castle, but in truth, this isn't the end of the story. It's only the beginning. At the time of this book's release, the Franklin Castle will have stood for 136 years. With proper care and respect, there's no reason it shouldn't stand for at least 136 more. The legends will continue. For as long as it stands, new tales are sure to be added, new people will one day take up residency and new events will unfold.

As for the ghosts, whoever they are, they'll always be a part of this story.

BIBLIOGRAPHY

Alexandria Gazette. August 21, 1890.

American Architect and Building News. "Summary of the Week, Cleveland, Houses." March 6, 1880.

Annals of Cleveland: Cleveland Foreign Language Newspaper Digest. Vol. 2. Cleveland, OH, 1937.

Baranick, Alana. "Michael DeVinko, 68, Owned a Castle, Married a Movie Star." *Plain Dealer* (Cleveland, OH), July 18, 2003.

Barensfeld, Tom. "New Life Comes to Old Franklin." *Cleveland (OH) Press*, May 1, 1982.

Bay Village: A Way of Life. Bay Village, OH: Bay Village Historical Society, 1974.

Beautiful Homes of Cleveland. Cleveland, OH: Cleveland Topics Company, 1917.

Biddle, Daniel R. "Chief Suspended, He'll Be Watched." *Plain Dealer* (Cleveland, OH), March 24, 1978.

———. "Fired Hongisto Blasts the Mayor: Kucinich Wants to Be President." *Plain Dealer* (Cleveland, OH), March 25, 1978.

The Biographical Encyclopedia of Ohio of the Nineteenth Century. Cincinnati, OH: Galaxy Publishing Company, 1876.

Birds Eye View of Cleveland, Ohio 1877. Chicago, IL: Shober & Carqueville, 1877.

The Book of Clevelanders: A Biographical Dictionary of Living Men in the City of Cleveland. Cleveland, OH: Burrows Book Company, 1914.

Boyko, John. *Blood and Daring: How Canada Fought the American Civil War and Forged a Nation.* Toronto: Knopf Canada, 2013.

Brown, Rusty. "Ghost Writer." *Plain Dealer* (Cleveland, OH), March 27, 1980.

Cassady, Charles. *Cleveland Ghosts.* Atglen, PA: Schiffer Publishing, 2008.

City Atlas of Cleveland, Ohio. From Official Records, Private Plans and Actual Surveys. Philadelphia, PA: G.M. Hopkins, 1881.

Cleveland Cemetery Records. Department of Parks, Recreation and Properties. Division of Park Maintenance & Properties. Cemetery Properties. Cleveland, Ohio.

Cleveland City Directory. Cleveland, OH, 1837–1952.

Cleveland Necrology File: 1850–1975. Cleveland Public Library, Cleveland, Ohio.

Cleveland (OH) Daily Herald. October 23, 1861.

Cleveland (OH) Leader (1886–1908).

Cleveland (OH) News (1929–49).

Cleveland (OH) Press (1886–1950).

Cleveland und sein Deutschthum. Cleveland, OH: German-American Biographical Publishing Company, 1897–98; 1907. (*Cleveland and Its Germans.* Translated by Steven Rowan. WRHS, 1989.)

Commemorative Biographical Record of Northwestern Ohio: Including the Counties of Defiance, Henry, Williams and Fulton. Chicago: J.H. Beers & Company, 1899.

Condon, George E. *West of the Cuyahoga.* Kent, OH: Kent State University Press, 2006.

Coshocton (OH) Tribune. July 12, 1975.

Daily News (Frederick, MD). October 30, 1915.

Darroch, Lois E. *Four Went to the Civil War.* Kitchener, ON: McBain Publications, 1985.

Defiance (OH) Democrat. April 23, 1870.

Dolgan, Robert. "Priest Sets Bail Benefit in Castle." *Plain Dealer* (Cleveland, OH), April 13, 1975.

Dorn, Clyde, Susan Marie Berg and Dave Stephenson. "Beyond Incredible: There's Nothing to Fear But." *Ohio Magazine,* November 1980.

Dreimiller, Barbara. "A Dream of Things that Were." *Western Reserve,* 1978.

———. "Franklin Castle's Fright Seeing tour." *Plain Dealer* (Cleveland, OH), February 28, 1975.

Eastlake, Charles Locke. *Hints on Household Taste in Furniture, Upholstery and Other Details.* Boston: J.R. Osgood and Company, 1872.

First Quadrennial Assessment of Real Property for Cleveland, 1910, Effective December 20, 1911. Cleveland, OH: Board of Assessors of Real Property, 1910.

Fort Wayne (IN) Daily News. September 8, 1912.

Frey, Christopher. *Die Bibliothek der Deutschen Sozialisten Cleveland, Ohio.* Wien, AUT: Inlibris, 2001.

Gaines, Michael. *The Shortest Dynasty, 1837–1947: The Story of Robert Portner: A History of His Brewing Empire, and the Story of His Beloved Annaburg.* Bowie, MD: Heritage Books, 2003.

Historical Sites of Cleveland. Columbus, OH: The Survey, 1942.

The History of North Royalton: 1811–1992. North Royalton, OH: North Royalton Historical Society, 1992.

History of the Central Ohio Conference of the Methodist Episcopal Church: 1856–1913. Cincinnati, OH: Press of the Methodist Book Concern, 1991.

Hoy, Claire. *Canadians in the Civil War.* Toronto, ON: McArthur & Company, 2004.

Industries of Maryland: A Descriptive Review of the Manufacturing and Mercantile Industries of the City of Baltimore. Baltimore, MD: Historical Publishing Company, 1882.

Insurance Maps of Cleveland, Ohio. New York: Sanborn Map & Publishing Company, 1886.

Insurance Maps of Cleveland, Ohio. Vol. 2. New York: Sanborn Perris Map Company, 1896.

Johannesen, Eric. *Cleveland Architecture, 1876–1976.* Cleveland, OH: Western Reserve Historical Society, 1979.

Johnson, Crisfield. *History of Cuyahoga County, Ohio, in Three Parts: First Part, General History of the County, Second Part, History of Cleveland, Third Part, History of the Townships: With Portraits and Biographical Sketches of Its Prominent Men and Pioneers.* Philadelphia, PA: D.W. Ensign & Company, 1879.

Kaib, Tom. "A Tale for Halloween." *Plain Dealer Sunday Magazine* (Cleveland, OH), October 28, 1973.

Kay, Leslie. "Old Castle's Present, Past Riddled with Fact, Fiction." *Plain Dealer* (Cleveland, OH), May 11, 1975.

Kennedy, James Harrison. *A History of the City of Cleveland: Its Settlement, Rise and Progress, 1796–1896.* Cleveland, OH: Imperial Press, 1896.

Krejci, William G. *Buried Beneath Cleveland: Lost Cemeteries of Cuyahoga County.* Charleston, SC: The History Press, 2015.

Leisy, Bruce R. *A History of the Leisy Brewing Companies.* North Newton, KS: Mennonite Press, 1975.

Livingston, Sandra. "Franklin Castle Is Condemned, Needs Repairs, Might Go on Sale." *Plain Dealer* (Cleveland, OH), September 13, 2010.

Lowing, Frank C. *History of the City of Lakewood.* Lakewood, OH: Fire and Police Pension Fund, 1915.

Maclay, Kathleen. "Hongisto Wedding: Love, Politics." *Plain Dealer* (Cleveland, OH), February 13, 1978.

Maxwell, Will J. *General Alumni Catalogue of the University of Pennsylvania, 1917.* Philadelphia, PA: Pennsylvania University General Alumni Society, 1917.

McIntyre, Michael K. "House of Horrors May End Soon." *Plain Dealer* (Cleveland, OH), October 30, 2010.

Medina County (OH) Gazette. September 7, 1976.

Memorial and Family History of Erie County New York, Volume 1, Biographical and Genealogical Illustrated. New York: Genealogical Publishing Company, 1906.

Men of Ohio. Cleveland, OH: Cleveland News, n.d.

Men of Ohio in Nineteen Hundred. Cleveland, OH: Benesch Art Publishing Company, 1901.

Mio, Lou. "Foreclosed Castle." *Plain Dealer* (Cleveland, OH), March 18, 1983.

Mueller, Werner Diebolt, and Duncan Buchanan Gardiner. *To Cleveland and Away: Of Muellers, Reids and Others.* Cleveland, OH: W.D. Mueller, 1993.

News Journal (Mansfield, OH). January 19, 1975.

New York Times. February 15, 1941.

O'Malley, Michael. "Boarded-up Franklin Castle Haunted by Foreclosure, Liens." *Plain Dealer* (Cleveland, OH), October 4, 2006.

O'Malley, Michael, and Joan Mazzolini. "New Strange Doings at Franklin Castle." *Plain Dealer* (Cleveland, OH), June 20, 2006.

One Hundred Years of Brewing: A Complete History of the Progress Made in the Art, Science and Industry of Brewing in the World, Particularly During the Nineteenth Century. Chicago: H.S. Rich & Company, 1903.

Payne, William. *Cleveland Illustrated. A Pictorial Handbook of the Forest City, Together with an Account of Its Most Attractive Suburbs.* N.p.: Fairbanks, Benedict & Company, 1876.

Petkovic, John. "New Life for an Old Haunt." *Plain Dealer* (Cleveland, OH), September 16, 2005.

Plain Dealer (Cleveland, OH) (1883–1975).

Plat Book of Cuyahoga County. Philadelphia, PA: G.M. Hopkins Company, 1914.

Post-Standard (Syracuse, NY). August 2, 1949.

Prince, Bryan. *My Brother's Keeper: African Canadians and the American Civil War.* Toronto, ON: Dundurn, 2015.

Proceedings of the Annual Convention of the American Institute of Architects. N.p.: American Institute of Architects, 1903.

Progressive Men of Northern Ohio. Cleveland, OH: Plain Dealer Publishing Company, 1906.

Quinn, Thomas J. "Fire Set in Castle of Spooky Legends." *Plain Dealer* (Cleveland, OH), November 8, 1999.

Richards, Beth A., and Chuck L. Gove. *Haunted Cleveland*. Charleston, SC: The History Press, 2015.

Riverside Cemetery Records. Cleveland, OH: Riverside Cemetery Association.

Scott, Beth, and Michael Norman. *Haunted Heartland*. Madison, WI: Stanton & Lee Publishers, 1985.

Smith, Joseph P. *History of the Republican Party in Ohio*. Chicago: Lewis Publishing Company, 1898.

"Spirited Debate." *Scene Magazine* (Cleveland, OH), July 23–29, 2003.

Strassmeyer, Mary. "His Home Is His Castle." *Plain Dealer* (Cleveland, OH), June 6, 1978.

———. "Unlucky Number." *Plain Dealer* (Cleveland, OH), March 22, 1983.

Sun (Baltimore, MD). August 23, 1890.

Swindell, Mary. "Their House Holds Haunting Memories." *Cleveland Press*, September 8, 1968.

Thay, Edrick. *Ghost Stories of Ohio*. Edmonton, AB: Ghost House Books, 2001.

Turner, Karl. "Man Accused in Castle Fire Lived in Shelter Next Door." *Plain Dealer* (Cleveland, OH), November 9, 1999.

U.S. Census Collection, 1790–1940.

U.S. Passport Applications, 1860–1925.

U.S. Supreme Court. *Supreme Court Reporter*. St. Paul, MN: West Publishing Company, 1883–1988.

Van Tassel, David D., and John J. Grabowski, eds. *The Dictionary of Cleveland Biography*. Bloomington: Indiana University Press, 1996.

———. *The Encyclopedia of Cleveland History*. 2nd ed. Bloomington: Indiana University Press, 1996.

Vickers, Jim. "Ghost Hunt." *Cleveland Magazine*, October 2001.

Vigil, Vicki Blum. *Cemeteries of Northeast Ohio: Stones, Symbols & Stories*. Cleveland, OH: Gray & Company Publishers, 2007.

Vishnevsky, Zina. "Franklin Castle Owner Plans Full Restoration." *Plain Dealer* (Cleveland, OH), April 17, 2000.

Wachter und Anzeiger (Cleveland, OH). July 17, 1937; September 8, 1937.

Ward, Dr. Robert E. *History of the Cleveland Germans*. Cleveland, OH, n.d.

Washington Law Reporter. District of Columbia Supreme Court (1863–1936); United States Court of Appeals (District of Columbia Circuit); District of Columbia Court of Appeals. Washington, D.C.: Powell & Ginck, 1893.

Washington Post. October 15, 1849.

Wiebenson, Walter Ernest. Memoirs. From a private collection.

Winer, Richard, and Nancy Osborn Ishmael. *More Haunted Houses.* New York: Bantam Books Inc., 1981.

Wolverton, A.N. *Dr. Newton Wolverton: An Intimate Anecdotal Biography of One of the Most Colorful Characters in Canadian History.* Vancouver, BC, 1933.

Woodyard, Chris. *Haunted Ohio III.* Dayton, OH: Kestrel Publications, 1994.

Wooster (OH) Daily Record. September 7, 1976.

Wright, G. Frederick. *Representative Citizens of Ohio: Memorial-Biographical.* Cleveland, OH: Memorial Publishing Company, 1918.

INDEX

William G. Krejci and John W. Myers at the Tiedemann family plot at Riverside Cemetery.
Courtesy of Mary Levtzow.